Flowers in Art

Contemporary International Artists

Cindy Ann Coldiron

Schiffer Publishing Ltd

4880 Lower Valley Road • Atglen, PA 19310

Copyright © 2012 by Cindy Ann Coldiron

Library of Congress Control Number: 2012949093

Designed by Justin Watkinson
Type set in UnivrstyRoman BT/ChopinScript/
 Helvetica Neue LT Pro/Zurich BT

ISBN: 978-0-7643-4239-4
Printed in China

Published by Schiffer Publishing, Ltd.
4880 Lower Valley Road
Atglen, PA 19310
Phone: (610) 593-1777; Fax: (610) 593-2002
E-mail: Info@schifferbooks.com

For the largest selection of fine reference books on this and related subjects, please visit our website at **www.schifferbooks.com.** You may also write for a free catalog.

This book may be purchased from the publisher. Please try your bookstore first.

We are always looking for people to write books on new and related subjects. If you have an idea for a book, please contact us at proposals@schifferbooks.com

Schiffer Books are available at special discounts for bulk purchases for sales promotions or premiums. Special editions, including personalized covers, corporate imprints, and excerpts can be created in large quantities for special needs. For more information contact the publisher.

In Europe, Schiffer books are distributed by Bushwood Books
6 Marksbury Ave.
Kew Gardens
Surrey TW9 4JF England
Phone: 44 (0) 20 8392 8585; Fax: 44 (0) 20 8392 9876
E-mail: info@bushwoodbooks.co.uk
Website: www.bushwoodbooks.co.uk

Disclaimer and Acknowledgements of Trademarks

Photo Credits:
Front Cover (background image):
Ida Pettersson
Front Cover: Ginny Ruffner, Nancy Monsebroten, Anne Duke, Ashley E. Cooke, Lauren Dunning, Ning Fan, Stan Ragets, Mary Aslin, and Joseph J. O'Neil.
Back Cover: Ann Sperling, Linda Lighton, Ashley E. Cooke, Michael Hilker, Ida Pettersson, Jennifer Peck
Spine: Pam Borrelli
Endsheets: Dániel Csóka

This book is dedicated to all the amazing flowers that bring color and beauty to our lives.

The butterfly is a flying flower,
The flower a tethered butterfly.

—Ponce Denis Écouchard Lebrun

Acknowledgments

I thank all the artists who worked with me to obtain the best possible photos of their work. I also thank the Sogetsu Society, the Metropolitan Washington, D.C. Branch, for allowing me to use photos of their Ikebana flower arrangements. Lastly, I thank Schiffer Publishing for providing me an opportunity to write a book on such a wonderful topic.

Contents

Introduction

I have always said that one can never have too many flowers. I wanted to write a book that focused on interesting and colorful floral-themed art in both two-dimensional and three-dimensional media. For an artist to be able to successfully capture the essence of a flower in a permanent form, much talent and dedication is required. Since no one person can be aware of every individual floral artist in the world, I held an international call for artist submissions that was heavily publicized in numerous art publications. I was pleased with the high volume of submissions for the book and only the best art work in terms of beauty, style, technique, and originality was selected for inclusion. Other artists received invitations to submit their work for the book based upon their reputation or my individual research.

This comprehensive overview of floral-themed art includes works by well known and established artists as well as emerging artists. Over fifty artists and designers from around the world are represented. The book includes photography, paintings, botanical drawings, ikebana design, pop art, glass, jewelry, wood, ceramics, collage, cutting edge digital fractal image work, and much more.

The book is divided into two main floral sections for ease of reference. Chapter One includes three-dimensional or sculptural art such as glass, ceramics, wood, and jewelry. Chapter Two includes two-dimensional works such as oil, watercolor, and acrylic paintings, botanical drawings, collage, pop art, and fractal images. The book concludes with some of my favorite floral quotes and a poem.

I have been an avid gardener since I was eight years old and never met a flower I did not appreciate. Every flower is a quiet explosion of form, color, and joy. In many cultures, flowers are a fixture in various occasions, both happy and sad. Flowers were likely received by our mothers when we were born and they will be sent to our families when our time on this earth comes to an end. And for all the occasions between birth and death, whether they be marriages, birthdays, holidays, illness, apologies, job promotions, or anniversaries, flowers will be given. Many years ago, a kind, elderly neighbor told me she never bought flowers for herself, since flowers had to be given as a gift. I always felt she was depriving herself of the beauty of having a constant vase of flowers in her home. Nothing adds more elegance and warmth to a room than a vase of flowers and I always have a vase of affordable colorful carnations or lilies on my dining room table.

Like many people, I feel that flowers are connected to many fond memories in my life. The summer before I left for college, my retired neighbor Alex (nicknamed "Olive" by me) and I had a sunflower competition to see who could grow the tallest flower. I watered that glorious sunflower every day and fertilized it weekly and prayed the squirrels would stay far away from it. It eventually grew to nearly nine feet in height and I won the competition by a little more than an inch. On another occasion, as a 14 year-old, I received a Christmas gift of a plant mailed once a month for a year. That was the year I discovered miniature roses and white gardenias. And of course, the late May blooming of the luscious pink and white peony bushes always signaled that school was about to end and summer fun was ready to begin.

But what exactly is a flower?

According to Wikipedia, a "flower, sometimes known as a bloom or blossom, is the reproductive structure found in flowering plants (plants of the division *Magnoliophyta*, also called angiosperms)."[1] "According to the fossil record," it says, "mosses were the first plants to emerge on land, some 425 million years ago, followed by ferns, firs, ginkgoes, conifers and several other varieties. Then, it seems, about 130 million years

ago flowering plants abruptly appeared out of nowhere."[2] Flowering plants are now the major type of plants found on earth today.[3]

We also learned in grade school that the flower is the part of the plant with the seeds and it is comprised of four parts: a stamen, pistil, petals, and sepals. In addition to being perfections in nature, the fragrance of most flowers, which probably developed biologically to attract insects, draws all of us to them as well.

Physical Properties of Flowers

Flowers can also have interesting and beneficial physical properties. Some are used for medicinal purposes, such as the Echinacea (also known as the "coneflower"). According to the Herbal Remedies Info website, "Native Americans originally discovered Echinacea medicinal uses when they found that it successfully healed wounds, infections, and other physical ailments."[4] Foxglove is used today to treat heart disease and chamomile is a commonly known flower that is used in tea to aid relaxation. Certain flowers ("pesticide free" only) may be edible while others will make you very ill. Carnations, wax begonias, dandelions, impatiens, nasturtiums, and pansies all have edible flowers.[5] According to the "What's Cooking America" website, carnations "can be steeped in wine, candy, or use as cake decoration." [6]

Floral Symbolism

Throughout history, specific flowers and flower colors have been connected to different meanings or symbolism. The astrological months of the year each have a designated flower, such as the morning glory for Virgo and the orchid for Aquarius.[7] We all know red roses signify love but yellow ones are commonly believed to symbolize friendship and pink ones can symbolize admiration. Lesser known symbolism includes sunflowers, which, "as a flower which blindly follows the sun, have become a symbol of infatuation or foolish passion." [8] The tiny and calm violet symbolizes faithfulness and the big dramatic hydrangea can mean vanity.[9]

This colorful symbolism also results in flowers being frequently referenced in music, religion, and literature. Flowers seem almost to speak their own unique language across various cultures and time periods. Roses seem to predominate in songs about flowers and we all have heard the 1980s song by Poison, "Every Rose Has Its Thorn," "The Rose" by Bette Midler, "The Yellow Rose of Texas" by Mitch Miller, and "Paper Roses" by Marie Osmond.

In the song "The Battle Hymn of the Republic" by Julia Ward Howe, the fifth verse contains the line "in the beauty of the lilies, Christ was born across the sea." Many lily varieties are believed to have originated in Asia and these flowers are strongly connected to the Christian faith. Any flower that is segregated into

three parts, such as the shamrock or the anemone, represents the Holy Trinity.[10] The holiest of flowers for Hindus, the beautiful lotus, is symbolic of the true soul of an individual. "It represents the being, which lives in turbid waters yet rises up and blossoms to the point of enlightenment."[11]

In literature, many writers are inspired by flowers in both a sad and joyful sense. Emily Dickenson wrote of "almost a loneliness" while hiding herself within her flower in the poem the "With a Flower." The poet William Wordsworth wrote of a "host of golden daffodils fluttering and dancing in the breeze" in the poem "I Wandered Lonely as a Cloud." The Bible tells us to "Consider the lilies of the field how they grow; they toil not, neither do they spin; And yet I say unto you, That even Solomon in all his glory was not arrayed like one of these." In the classic story of *The Little Prince*, by Antoine de Saint-Exupéry, the vain and proud rose wanted the little prince to stay with her and not travel. In "Life Thoughts" by author and minister Henry Ward Beecher, he said "Flowers are the sweetest things God ever made, and forgot to put a soul into."

Flowers in Visual Art

Since colorful flowers are something that would visually capture one's attention, early cave dwellers painted and drew images of animals, humans, trees, and flowers on cave walls. As civilization progressed, flowers were used in paintings and drawings and sculpture to communicate religious themes. Flowers in Christian art symbols date back to early times when the majority of ordinary people were not able to read or write, and printing was unknown.[12] Ikebana, which is the art of Japanese flower arrangement, developed from a Buddhist worship practice to an independent art form after the 15th century.[13]

From the 17th through 19th centuries, flowers became a widely used motif in painting, generally symbolizing the "romantic notion that the delights of this world are transitory and perishable."[14] During the 17th and 18th centuries, botanical art, which involves drawing anatomically correct scientific illustrations of the structures of flowers and their roots, became very popular. Subsequent to this, flowers came into mainstream popularity and numerous influential iconic artists are associated with floral images. In the last one hundred-fifty years, we have been blessed with Claude Monet and his water lilies, Vincent Van Gogh and his sunflowers, Georgia O'Keefe and her large and intricate flowers, Andy Warhol with his pop art flower paintings, and Dale Chihuly with his blown glass flowers.

Floral-themed art in all media is more popular than ever today. Whether one enjoys simply reflecting on these perfections in nature or exploring artistic media for floral expression, I hope the work of the artists in this book provide inspiration to all.

Three-Dimensional Floral Art

The fourteen artists and designers profiled in this chapter demonstrate the level of expertise and talent needed to successfully translate the beauty, form, and spirit of flowers into sculptural media. From the internationally renowned Ginny Ruffner with her stunning lampworked creations to the joyful torch-worked necklaces of Debra Dowden-Crockett, to the unpretentious and elegant ikebana floral arrangements of Jane Redmon and Keith Stanley, I hope these works bring reflection and inspiration of flowers yet to come.

Ginny Ruffner

Seattle, Washington, United States

Distinguished glass artist Ginny Ruffner's organic floral sculptures employ the technique of lampwork or flame work. This involves heating and fusing multiple glass elements together. Her distinguished career spans more than three decades and her painterly and botanically themed sculptures are in collections worldwide.

WEBSITE: www.ginnyruffner.com

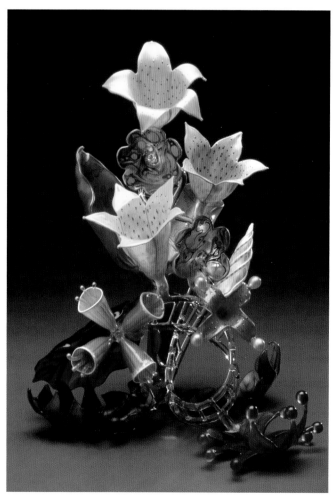

Inventing Flowers, 2005. 24" x 18" x 17", lamp-worked glass and mixed media. *Photo courtesy of Mike Seidl.*

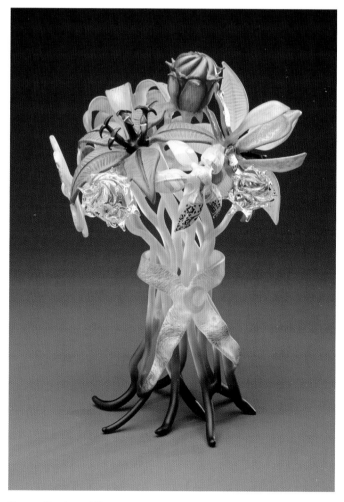

Secret Desires of Paintings, 2006. 20" x 14" x 14", lamp-worked glass and mixed media. Photo *courtesy of Mike Seidl.*

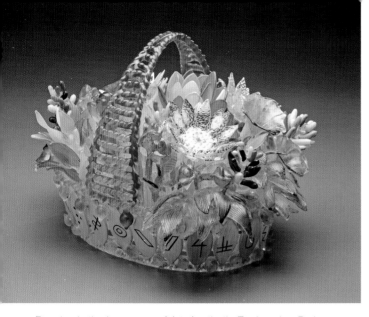

Drawing is the Language of Art, Aesthetic Engineering Series, 2008. 12" x 17" x 12", lamp-worked glass and mixed media. *Photo courtesy of Mike Seidl.*

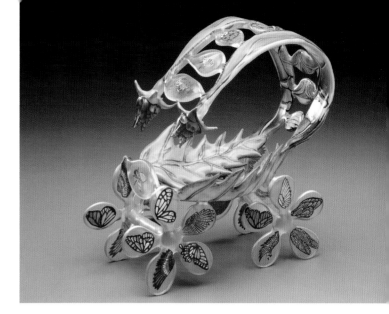

Wing Buggy, 2009. 12" x 13" x 8", lamp-worked glass and mixed media. *Photo courtesy of Mike Seidl.*

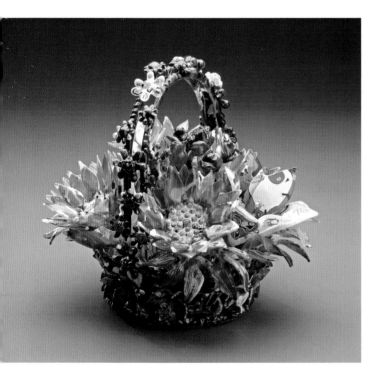

Pointillistic Flora Painting, Aesthetic Engineering Series, 2010. 13" x 15" x 15", lamp-worked glass and mixed media. *Photo courtesy of Mike Seidl.*

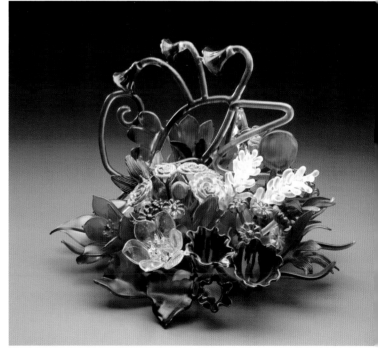

Finding Geometry in Nature, 2010. 14" x 18" x 15", lamp-worked glass and mixed media. *Photo courtesy of Mike Seidl.*

David Kennedy

Slade, New Ross, Wexford, Ireland

Flowers are universal; they stand for life, love and indeed death. When I see irises I think of Van Gogh and Louis Tiffany, so that sets the bar pretty high. The main inspiration for this piece was the glass used in the blooms and the background glass which both contain blue. The design is completely made up, the only influence being the glass I have available which of course suggests irises.

Hydrangeas grow everywhere in Ireland in a multitude of color combinations. I had always wanted to try them in stained glass because I feel they represented a real challenge. The initial thumbnail sketch took me about half an hour but the full size pattern took about four days to get right. I just try and capture the colors and feel of the flowers using the glass I have available. I am trying to stop the viewers in their tracks, make them catch their breath so to speak and take a little time to look at the beautiful world we live in.

WEBSITE:
www.kennedyoriginalstainedglass.com

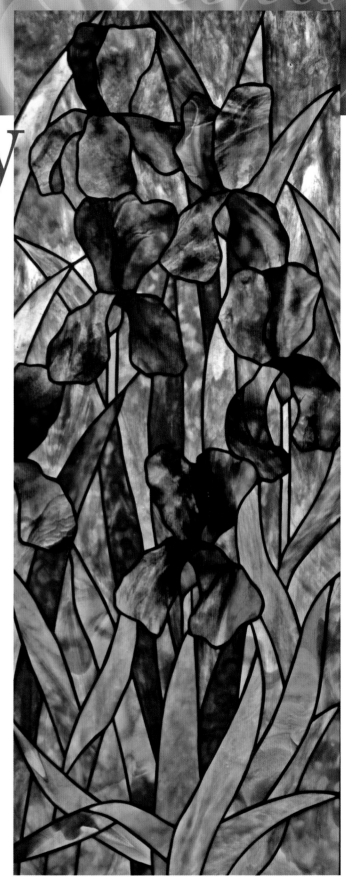

Moody Irises, 2010. 37" x 14.5", copper-foiled stained glass panel.
Photo courtesy of Sharon Kennedy.

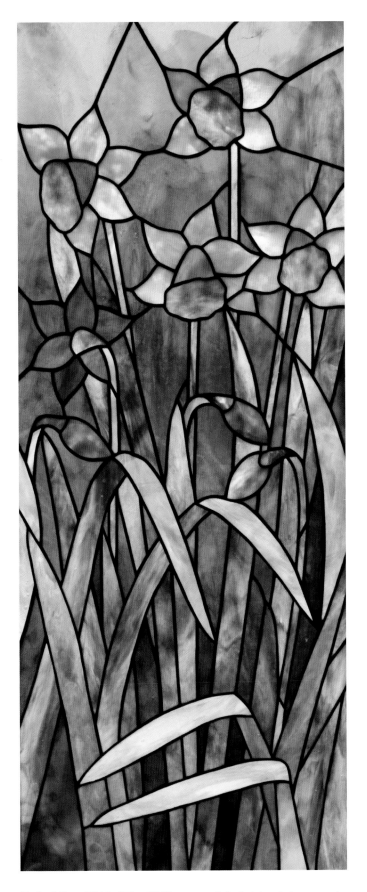

Daffodil Day, 2011. 37" x 15.3", copper-foiled stained glass panel.
Photo courtesy of Sharon Kennedy.

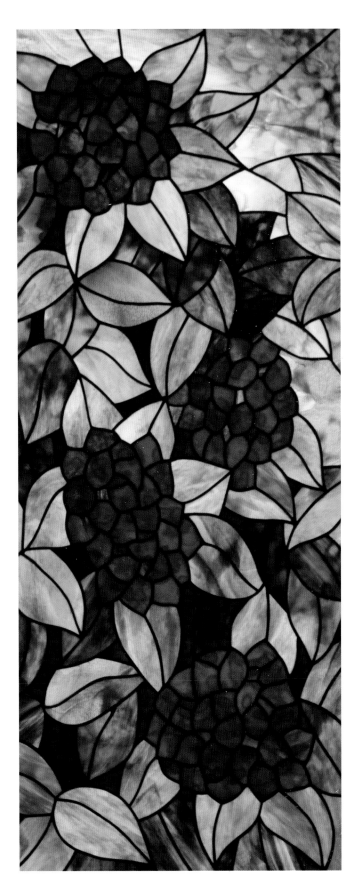

Hydrangea, 2011. 37" x 15.3", copper-foiled stained glass panel.
Photo courtesy of Sharon Kennedy.

Chris Heisinger

Evanston, Illinois, United States

I have traveled to various wild forests and woods and I am amazed by the beauty and high energy of all of those magnificent places. It is these places in which I stop and become one with the environment. The colors, sounds, and smells are intense and profound. It is these experiences that I try to capture in time within my art.

By being aware of the fragility of nature and our ecosystem, I try to use as much recycled material as possible with all my artwork. Most of my window pieces are actually old recycled window frames and a significant amount of the stained glass used in the pieces are either scraps from other projects or glass that would have otherwise been thrown out.

WEBSITE: www.heisingerdesign.com

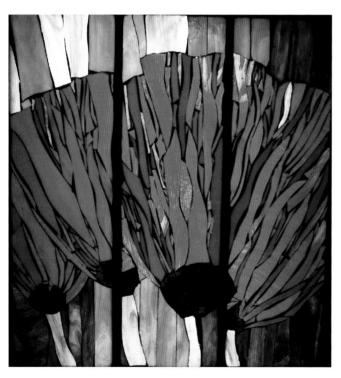

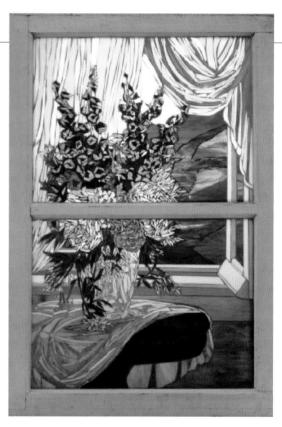

Poppy/Poppies, 2009. 33" x 32", stained glass mosaic window. *Photo courtesy of the artist.*

Peonies in the Sun, 2008. 32" x 26", stained glass mosaic window. *Photo courtesy of the artist.*

Nadine Beth
Schneider

Ashburn, Virginia, United States

I have worked in stained glass for over thirty years and have created floral panels right from the start. There are so many beautiful flowers and an infinite number of colors! You never run out of ideas for designs. Another thing about flowers is everyone loves them and they never tire of looking at them! The one aspect of design work, whether for me personally or for a client, that often concerns me when I begin a project is will it be as fresh next year when it is seen as it is the day it is installed. When I design with flowers my doubts are soon put aside. Rather than seeing the same thing every day, people often focus on different flowers and parts and see something different every time!

WEBSITE: www.nadinesfolly.com

Texas Bluebonnets, 2006. 26" x 26" x 3",
three-dimensional stained glass panel.
Photo courtesy of the artist.

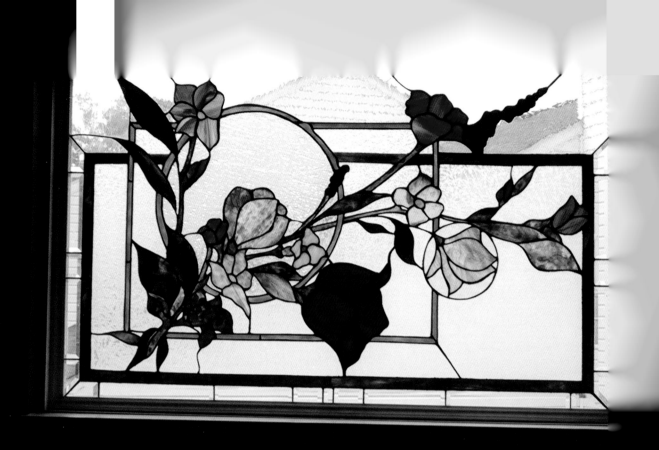

Bathroom Bouquet, 2003. 57.25" x 34", beveled and stained glass p[...] *Photo courtesy of the artist.*

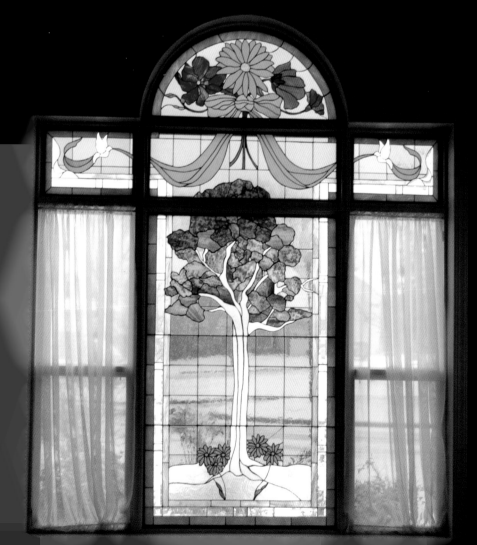

Tree of Life in Snow, 2000. 112" x 94.5"

Andrea Kelter

New Glasgow, Nova Scotia, Canada

Florals are beautifully expressed through the medium of stained glass due to the fluid and ever-changing nature of glass which mimics Mother Nature beautifully. Long a subject of stained glass artists, most notably Louis Comfort Tiffany whose floral lamps are prized by collectors around the world, I saw an opportunity to take the traditional expression of florals in stained glass (which tends to be interpretive) and render a more modern expression based in realism.

Tulip Frolic captures the glory of spring through the dance of flowers on a blue and breezy day. Resembling a patch of tulips growing in a garden plot, this lamp is aesthetically pleasing whether lit or unlit. The bold colors of the flowers, and the many shades of green found in this lamp add depth and realism to the piece, making it a focal point of any room or home.

WEBSITE: www.earthglassstudio.com

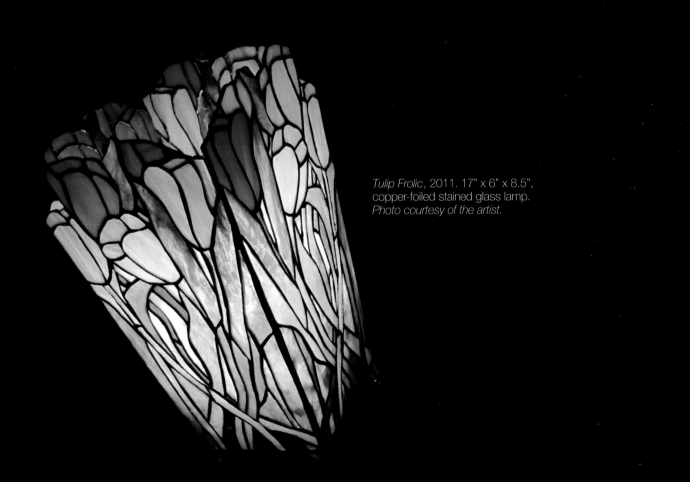

Tulip Frolic, 2011. 17" x 6" x 8.5", copper-foiled stained glass lamp. *Photo courtesy of the artist.*

Leisa
Artus

Greer, South Carolina, United States

To me, working with glass is all about vibrant color and pure design. I find such joy in working with glass and in the beauty of flowers. To me, creating flowers from glass is natural progression.

I create my glass artwork and jewelry using Bullseye and Wissmach sheet glass, Glassline paint, and enamel paint. Canvas boards and acrylic paints are sometimes used in mounting and framing glass tile artwork. Much of my glass work is done by hand cutting and piecing glass designs. I often hand paint these designs with Glassline paint and then kiln-fire. The work may involve several layers of glass and paint and require multiple firings. Sometimes, after the glass is fired, I may add detail with enamel paint and then bake the glass piece to set.

WEBSITE: www.Leisaworks.blogspot.com

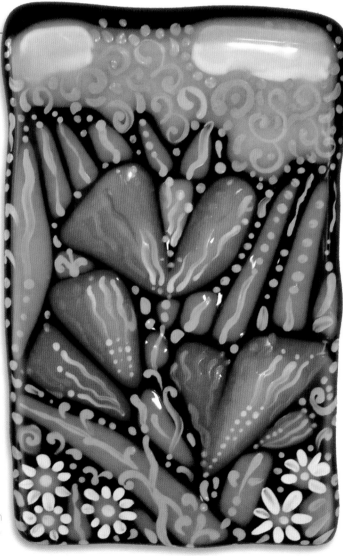

Consider the Lilies, 2011. 4" x 3" x 0.25", fused glass tile with enamel paint detail. *Photo courtesy of the artist.*

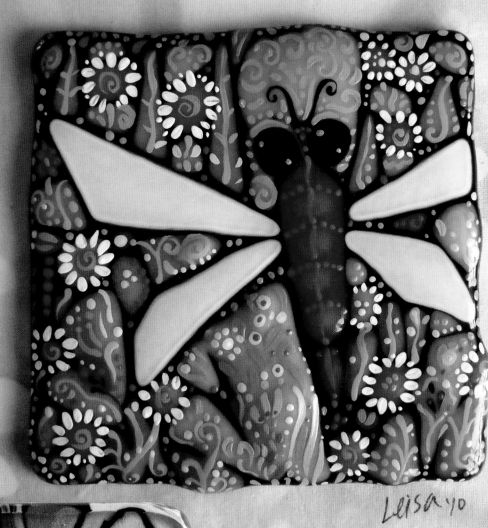

Garden Flight, 2010. 5" x 5" x 0.25", fused glass tile with enamel paint detail. *Photo courtesy of the artist.*

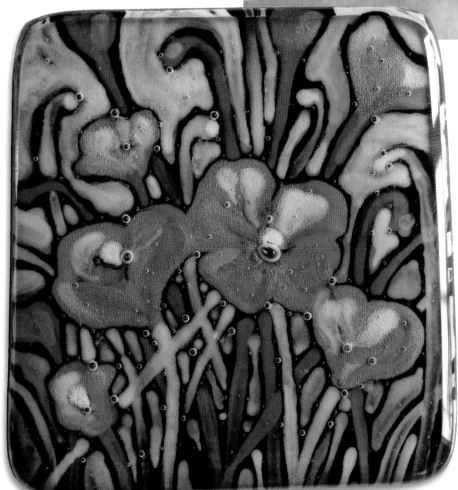

Poppies, 2010. 5" x 5" x 0.25", fused glass tile with Glassline paint detail. *Photo courtesy of the artist.*

Debra Dowden-Crockett

Norfolk, Virginia, United States

My love for glass began in college as a chemistry student, where I was required to take glassblowing classes to create equipment for experiments. Much to my professor's dismay, I began my own experiments of creating sticks, pods, flowers, buds, and leaves. My love for flowers, as well as all things bright and colorful, has been life-long and has led me in the creation of sculpture and wearable art glass reflecting my thoughts, artistic vision, and my need for unique expression.

Using my torch to gently coax the glass into unique shapes and to capture the intricate details and components of flowers, I follow each inspiration and idea in duplicating the colors, shapes, and complexity I find in nature. I replicate flowers in glass to perhaps hold on to their fleeting beauty and essence and to create a more permanent likeness. I am fascinated by the power they have to influence our consciousness and sentiment. Throughout history, flowers have been the object of mania, inspiration, friendship, passion, and adornment. By both their form and function, flowers have the ability to evoke strong feelings of awe, fascination, contentment, comfort, happiness, love, and lust. As a glass artist, if I can capture or convey a small portion of this emotion in my work, I have achieved success.

WEBSITE: www.glassinbloom.com

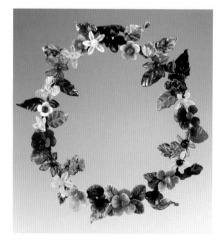

Ring Around The Posies, 2009. 11.5" x 4" x 2.5", flame worked glass wreath with sculpted annealed copper *Photo courtesy of the artist.*

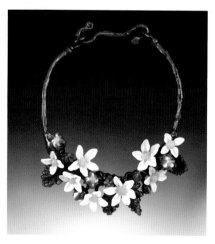

Pick More Daisies – Have No Regrets, 2008. 17" x 2.5" x 2.5", flame worked glass necklace with sculpted annealed copper. *Photo courtesy of the artist.*

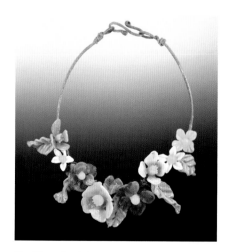

So Blue, But Happy, 2011. 17" x 2.5"x 2.5", flame worked glass necklace with sculpted annealed copper. *Photo courtesy of the artist.*

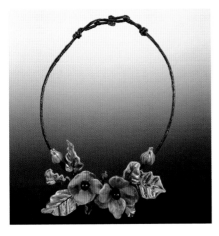

Silver Plum Splendor, 2011. 17.5" x 3" x 2.5", flame worked glass necklace with sculpted annealed copper. *Photo courtesy of the artist.*

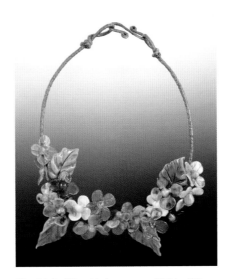

The Hail of the Hydrangeas, 2011. 17" x 2.5" x 2.5", flame worked glass necklace with sculpted annealed copper. *Photo courtesy of the artist.*

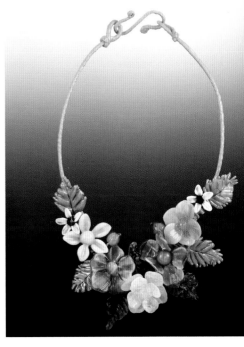

Pretty in Pink Posies, 2011. 17" x 2.5" x 2.5", flame worked glass and sculpted annealed copper. *Photo courtesy of the artist.*

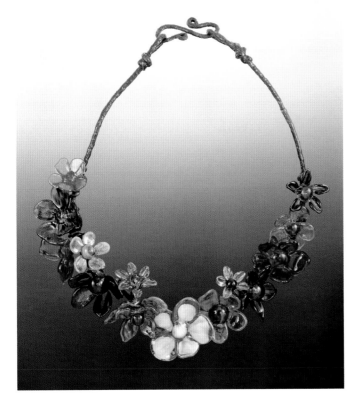

Brilliantly Blue Blossoms, 2011. 17" x 2.5" x 2.5", flame worked glass and sculpted annealed copper. *Photo courtesy of the artist.*

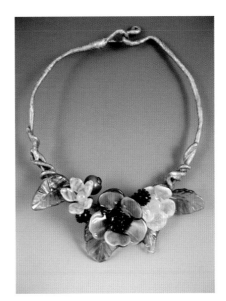

Violet Medley, 2008. 17" x 2.5" x 2", flame worked glass and sculpted annealed copper. *Photo courtesy of the artist.*

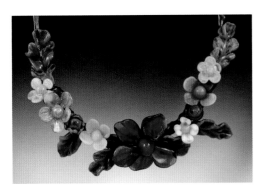

Spring Awakening, 2009. 17" x 2.5" x 2.5", flame worked glass and sculpted annealed copper. *Photo courtesy of the artist.*

Sherry G. Selevan

Silver Spring, Maryland, United States

I made the piece *Whenever I See Orchids . . .* in memory of an old friend. She loved orchids, and had that magic touch with them. The flowers shown here were based on my photographs of her orchids. To make this a communal effort, her friends and relatives wrote the phrase "Whenever I see orchids . . ." which I sandblasted into the layers of glass. The imagery floats on different layers of glass, and gives a sense of depth and transition.

WEBSITE: www.sgs-artglass.com

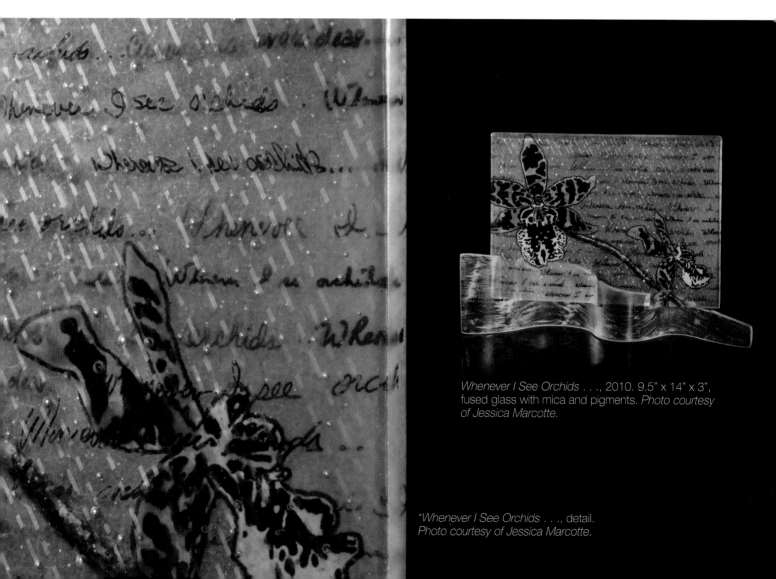

Whenever I See Orchids . . ., 2010. 9.5" x 14" x 3", fused glass with mica and pigments. *Photo courtesy of Jessica Marcotte.*

"Whenever I See Orchids . . ., detail. *Photo courtesy of Jessica Marcotte.*

Carolyn Schlam

Taos, New Mexico, United States

Glass is such a beautiful medium to work with and these flower plates express both the joyousness of the flower and of the glass itself. A perfect marriage of subject and medium!

The flower plates are made of colored glass which has been cut and pieced together, then fused in a kiln. The finished plate is then slumped into a clay mold.

WEBSITE: www.carolynschlam.com

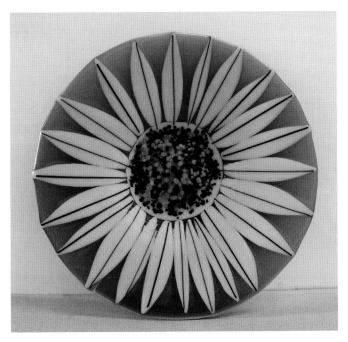

Sunflower Plate, 2010. 13" x 13" x 0.25", fused and slumped glass. *Photo courtesy of the artist.*

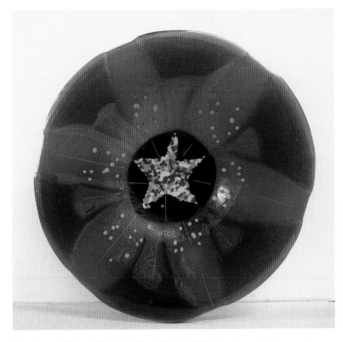

Starflower Plate, 2010. 13" x 13" x 0.25", fused and slumped glass. *Photo courtesy of the artist.*

Nancy Monsebroten

Onalaska, Wisconsin, United States

The flower is so simple. It is something about finding the most amazing beauty in the most ordinary of places. The beautiful yellow of the first dandelion of the season, the amazing black center of a poppy blossom in my garden, the lovely purple of a wild violet in the ditch, who can really say where it all comes from? The older I grow the more reverence I feel not only for flowers, but for all of the beauty, mystery and wonder I find in nature.

Most of my ceramic vases are wheel thrown and the petals are then hand built and attached separately. The Thousand Petal Vase actually has one thousand petals. (I counted). These pieces are very time consuming but I find that working on them becomes a form of meditation for me. I feel very grateful to find myself at a point in my life where I can do this work.

WEBSITE: www.whiteearthceramics.com

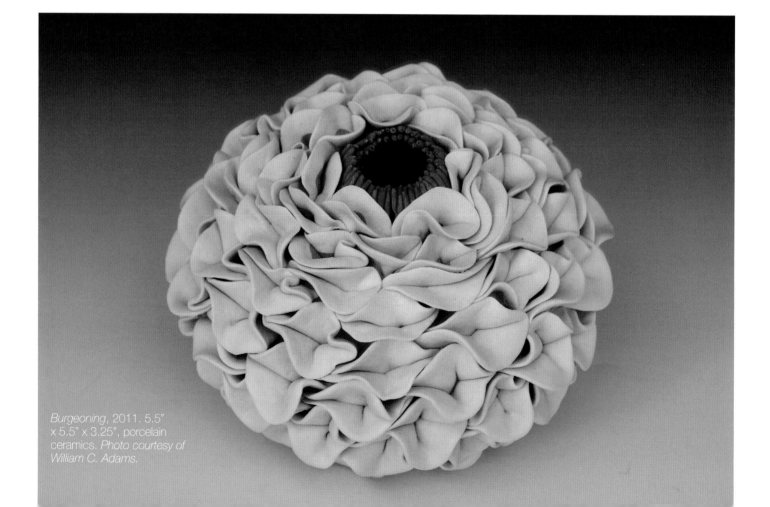

Burgeoning, 2011. 5.5"
x 5.5" x 3.25", porcelain
ceramics. *Photo courtesy of
William C. Adams.*

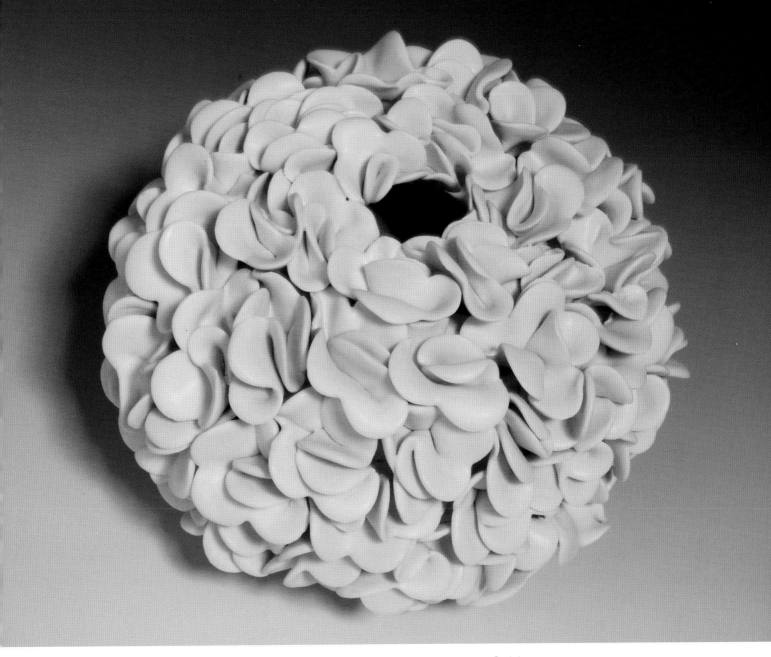

Thousand Petal Vase, 2011. 5.25" x 5.25" x 4", porcelain ceramics. *Photo courtesy of William C. Adams.*

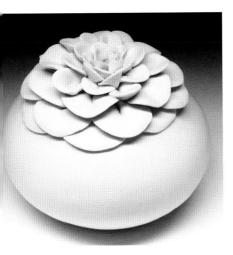

Lotus Vase, 2010. 4.25" x 4.25" x 3.25", porcelain ceramics. *Photo courtesy of Robert Metcalf.*

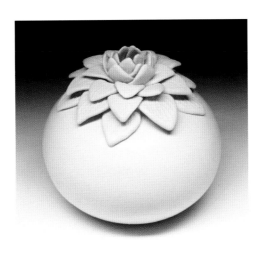

Lotus Vase, 2010. 5" x 5" x 5", porcelain ceramics. *Photo courtesy of Robert Metcalf.*

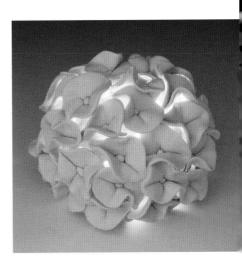

Blossom Tea Light Holder, 2011. 4" x 4" x 3", porcelain ceramics. *Photo courtesy of William C. Adams.*

Linda Lighton

Kansas City, Missouri, United States

My sculptures are defined by their sensuality, fertility and empowered sexuality. The work explores various microcosms and the details within. This group of sculptures evolved from the ideas of growth and transition, from the feminine point of view. I have been studying tubeworms and mollusks, as well as orchids and the sex of flowers.

I am interested in the life force; a dangerous beauty entailing seduction, sexual prowess, and moaning hormones. I want to celebrate the spirit of life. The work, two-stepping towards figuration, beckoning seductively, singing the high notes for recognition. They beckon the viewer to come closer, "come hither." I want to make something gorgeous and elegant. Oh my God, have I gone over the line? Is this baroque-a-go-go? I wish my work to smell of the sea, have colors as soft and slippery as a satin quilt and taste the effervescent, tingle of pink. Succulent!

Constructing a piece can take up to a week. Then the firings begin with a bisque firing and then one or two glaze firings. Color is integral. I animate the work with the application of China paints and lustres, often firing up to ten times. Each piece takes two to three months to finish, although I can work on several pieces at a time. I consider the works organic as well as figurative.

WEBSITE: www.lindalighton.com

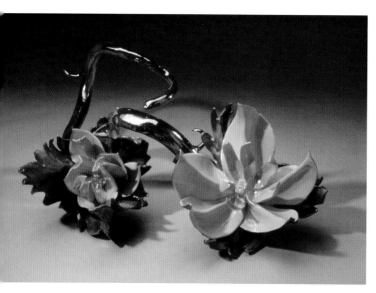

Cotton Boll, 2004. 32" x 30" x 19.5", clay and glaze with lustres. *Photo courtesy of the artist.*

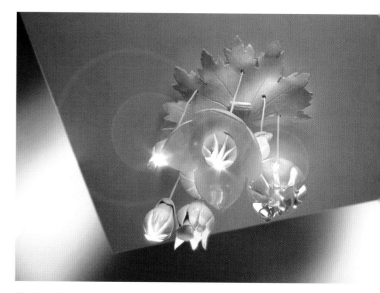

Fuchsia Chandelier, 2009. 23"x 20" x 36", porcelain, glaze, halogen lights and silk cord. *Photo courtesy of the artist.*

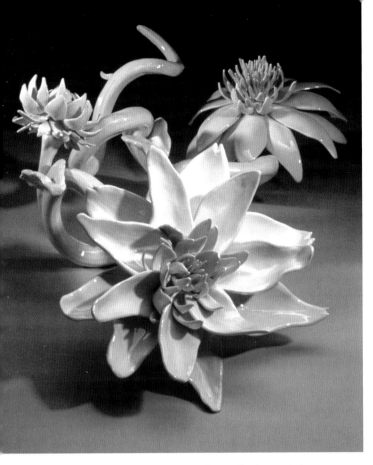

Triple White Zinnia, 2005. 40" x 23" x15.5", clay and glaze. *Photo courtesy of the artist.*

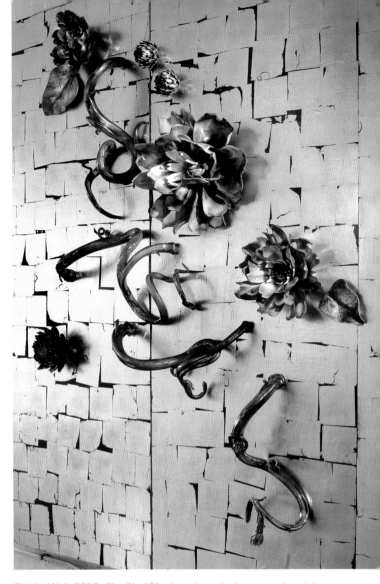

Thistle Wall, 2005. 9' x 8'x 12", clay, glaze, lustres, wood, paint, and bronze leaf. *Photo courtesy of the artist.*

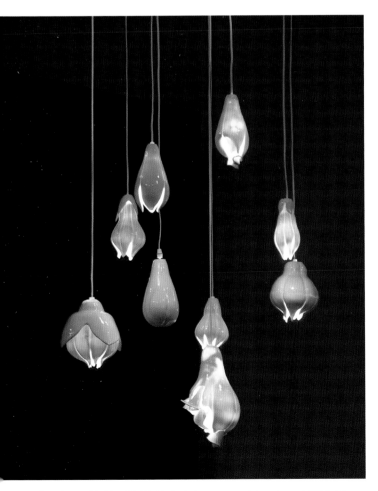

Luminous Lights, 2010. Varied sizes, porcelain, glaze, LED lights and silk cord. *Photo courtesy of the artist.*

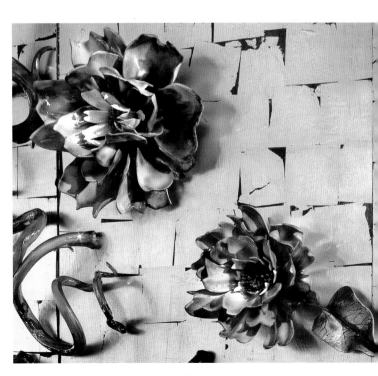

Thistle Wall, detail. *Photo courtesy of the artist.*

Mark
Behme

Silver Spring, Maryland, United States

My intent was to make a tribute guitar to the band of the same name, but as elegant and beautiful as I could carve. This is a fully functional four-string bass guitar. All the hardware components are thoughtfully integrated into the composition as much as possible. The pickups are in the grips of the guns, which in their chrome-plated and linear coldness are a stark contrast with the organic and realistically hand-carved-and-painted bright yellow roses.

WEBSITE: www.markbehme.com

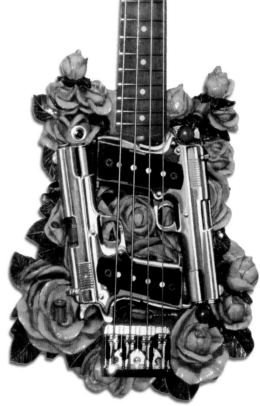

Guns and Roses, 2011. 37" x 13" x 5", yellowheart, canary, bloodwood, enamel and hardware. *Photo courtesy of the artist.*

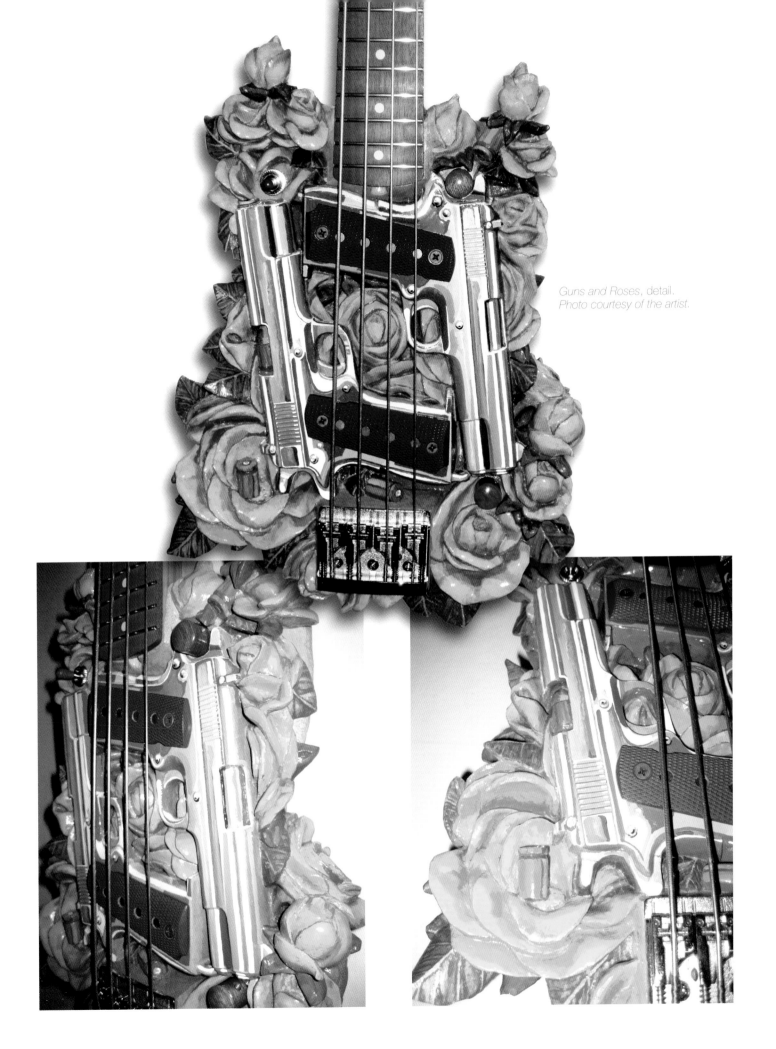

Guns and Roses, detail.
Photo courtesy of the artist.

Ikebana
The Art of Japanese Floral Arrangement

Ikebana Arrangement with Dried Sunflowers and Trifoliate Orange, 2011. Design by Keith Stanley, Sogetsu School, Metropolitan Washington, DC Branch. 13"x 11" x 24". *Photo courtesy of Keith Stanley.*

Jane Redmon
& Keith Stanley
Ikebana Designers

Ikebana or Japanese flower arrangement means "living flowers" or "giving life to flowers." Ikebana designers use flowers and other plant materials to create beauty, and Ikebana is reflective of Japan's deep connection with nature. Arrangements are designed to enhance the beauty of the flowers and other material, as well as line, space, mass, and color.

The following photos show arrangements by designers of the Sogetsu School of Ikebana, headquartered in Tokyo, Japan, Metropolitan Washington, D.C. Branch.

WEBSITE: www.sogetsuwashingtondc.org

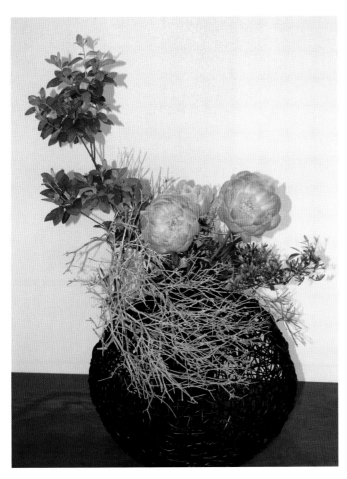

Ikebana Arrangement with Peonies, Fresh and Colored Azalea Branches, 2011. Design by Jane Redmon, Sogetsu School, Metropolitan Washington, DC Branch. 22" x 18" x 18". Photo courtesy of Fay McLaren.

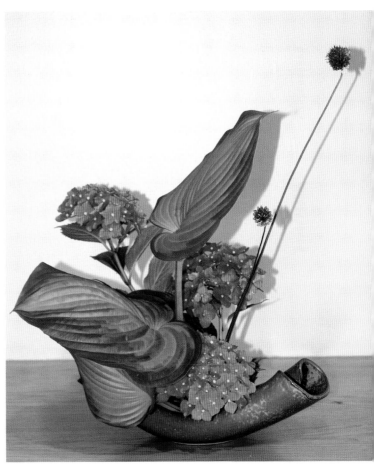

Ikebana Arrangement with Hydrangea, Allium, and Hosta, 2011. Design by Keith Stanley, Sogetsu School, Metropolitan Washington, DC Branch. 16" x 6" x 14". Photo courtesy of Fay McLaren.

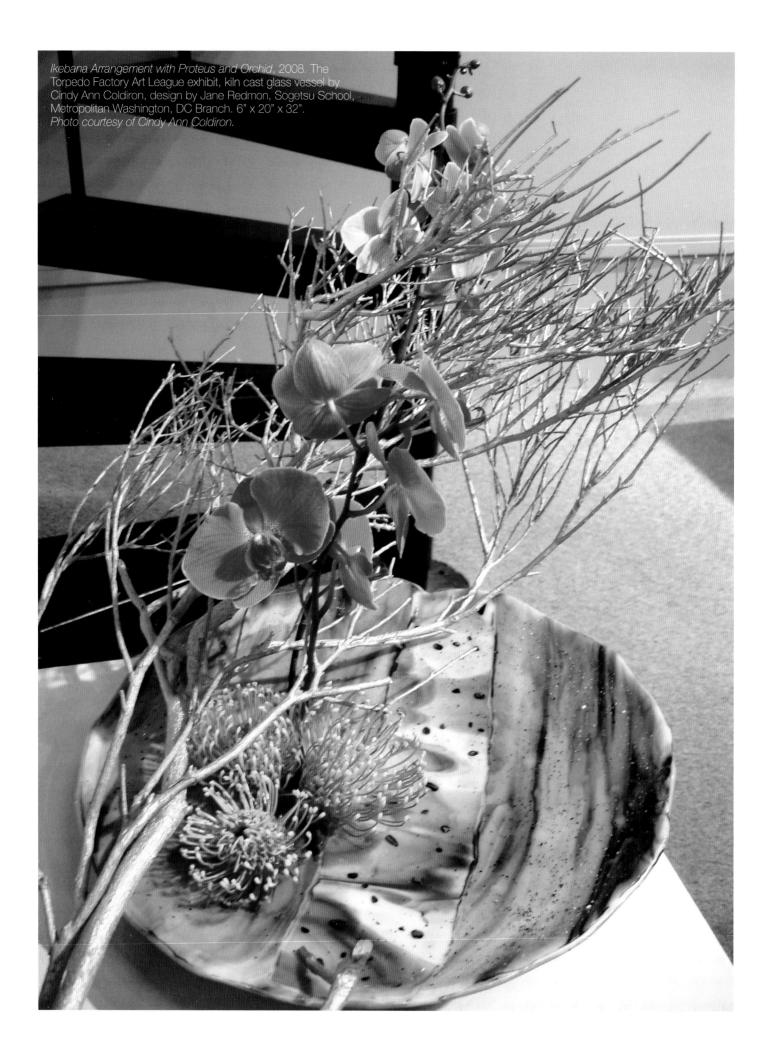

Ikebana Arrangement with Proteus and Orchid, 2008. The
Torpedo Factory Art League exhibit, kiln cast glass vessel by
Cindy Ann Coldiron, design by Jane Redmon, Sogetsu School,
Metropolitan Washington, DC Branch. 6" x 20" x 32".
Photo courtesy of Cindy Ann Coldiron.

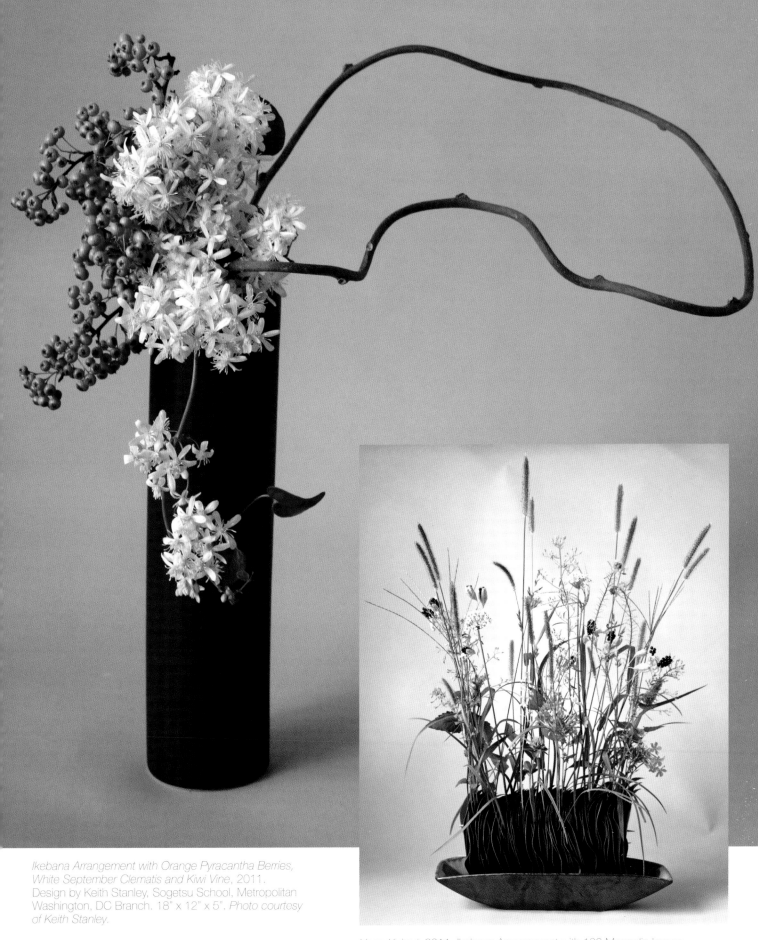

Ikebana Arrangement with Orange Pyracantha Berries, White September Clematis and Kiwi Vine, 2011. Design by Keith Stanley, Sogetsu School, Metropolitan Washington, DC Branch. 18" x 12" x 5". Photo courtesy of Keith Stanley.

Hana Kubari, 2011. Ikebana Arrangement with 100 Magnolia leaves, Bamboo Skewers, Grasses, Summer Phlox, Bulbine Frutescens, White Garlic Flowers, Blackberry Lillies, Hyssop, Salvia", design by Keith Stanley, Sogetsu School, Metropolitan Washington, DC Branch. 24" x 16" x 6". Photo courtesy of Keith Stanley.

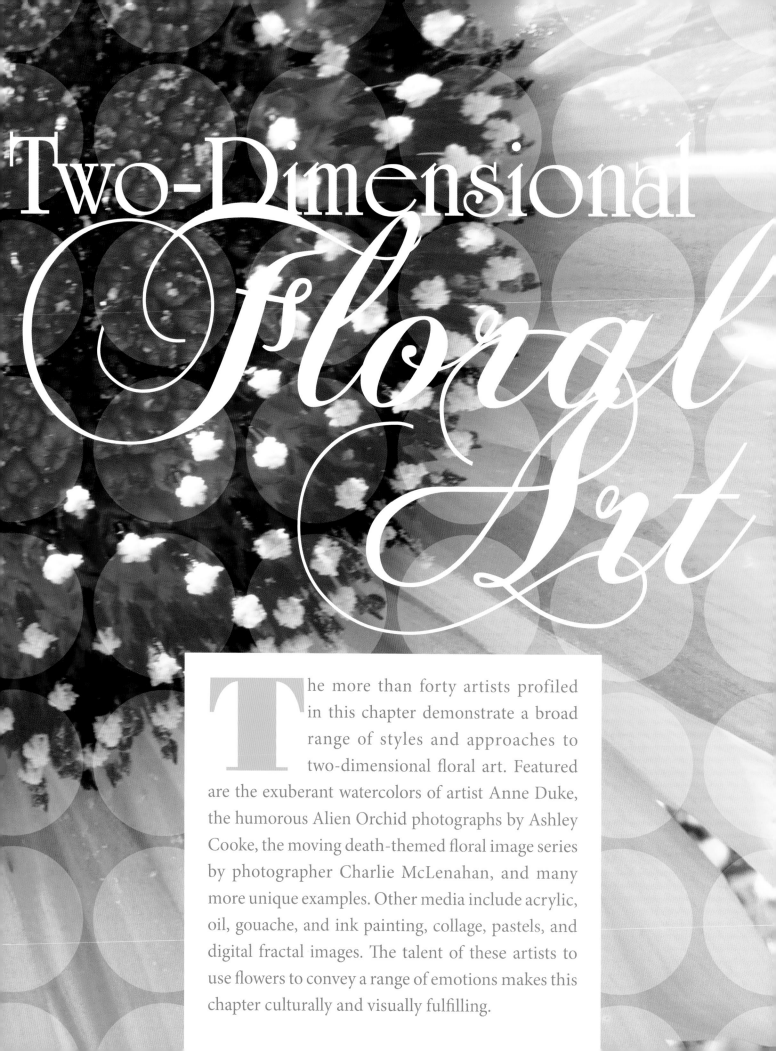

Two-Dimensional *floral Art*

The more than forty artists profiled in this chapter demonstrate a broad range of styles and approaches to two-dimensional floral art. Featured are the exuberant watercolors of artist Anne Duke, the humorous Alien Orchid photographs by Ashley Cooke, the moving death-themed floral image series by photographer Charlie McLenahan, and many more unique examples. Other media include acrylic, oil, gouache, and ink painting, collage, pastels, and digital fractal images. The talent of these artists to use flowers to convey a range of emotions makes this chapter culturally and visually fulfilling.

Anne Duke

Needles, California, United States

My mother had a green thumb and my father was a botanist. As my three sisters and I grew up, we were influenced by our mother's pleasure in her flower gardens and our father's love of hiking the mountains and the desert of the Mojave.

The subjects of many of my paintings are these same flowers, trees, and mountains. My watercolor paintings are my attempt to express the essence of a lifetime of appreciation for the beauty of God's creation. It is my joy to paint and to share this appreciation with others.

WEBSITE: www.anne-duke.artistwebsites.com

Poppy Play, 2011. 5" x 7", watercolor painting. *Photo courtesy of the artist.*

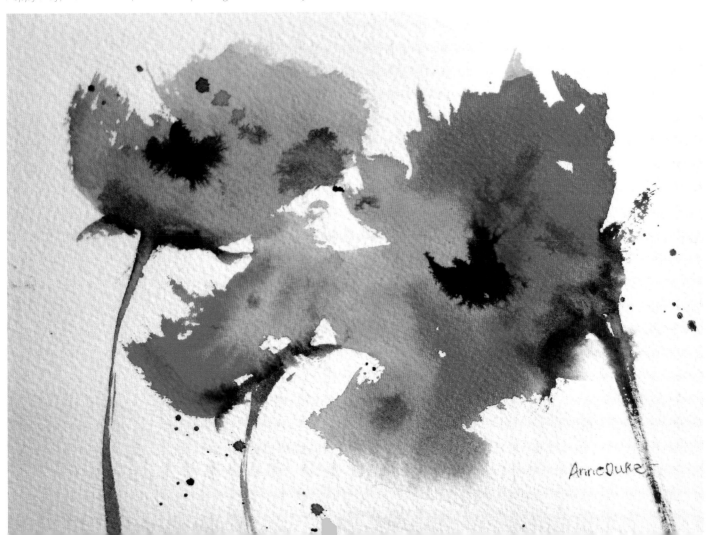

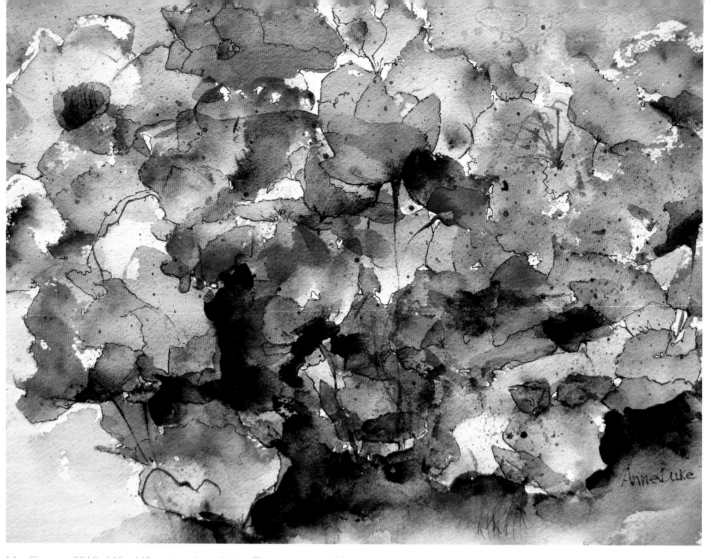

May Flowers, 2010. 11" x 14", watercolor painting. *Photo courtesy of the artist.*

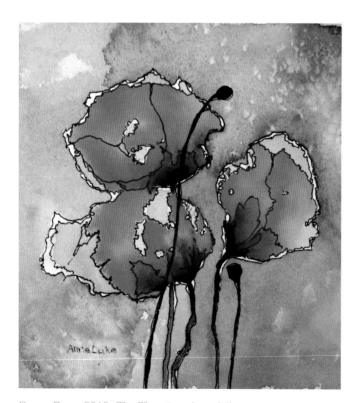

Poppy Pose, 2010. 7" x 7", watercolor painting.
Photo courtesy of the artist.

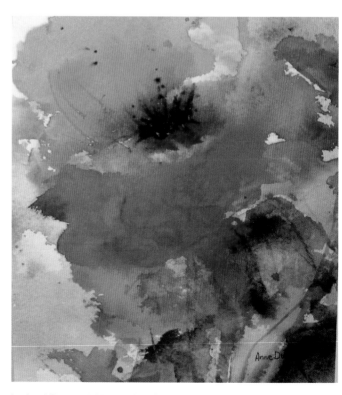

Iceland Poppy, 2009. 10" x 8", watercolor painting.
Photo courtesy of the artist.

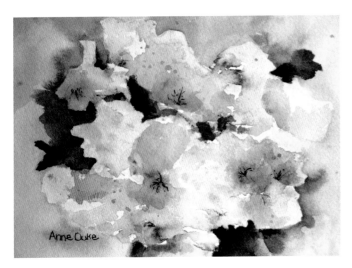

Orchard Blossom, 2011. 5" x 7", watercolor painting.
Photo courtesy of the artist.

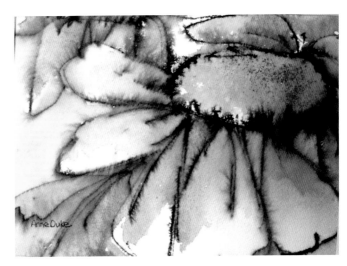

Daisy Dance, 2011. 6" x 8", watercolor painting.
Photo courtesy of the artist.

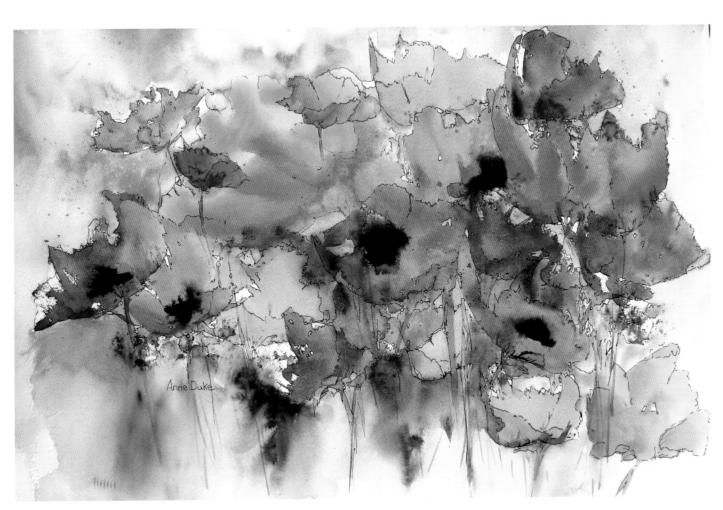

Floral Fantastic, 2011. 15" x 22", watercolor painting. *Photo courtesy of the artist.*

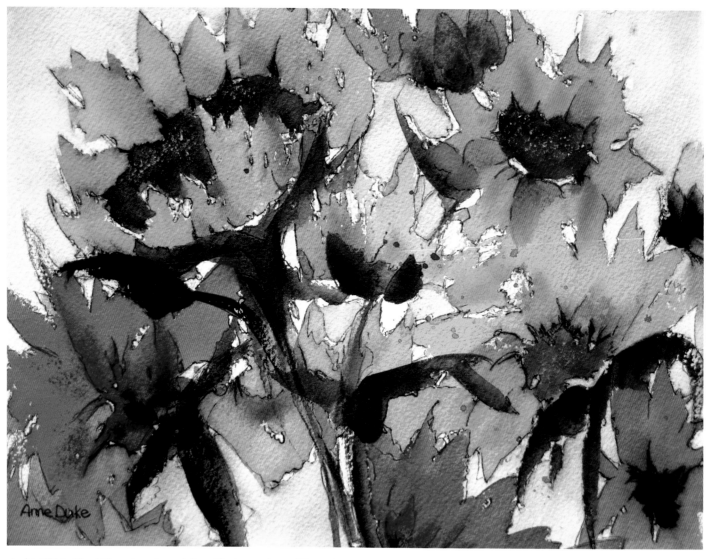

Joyful, 2011. 8" x 11", watercolor painting. *Photo courtesy of the artist.*

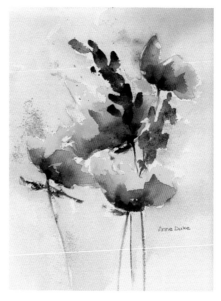

Meadow Muse, 2010. 11" x 9", watercolor painting. *Photo courtesy of the artist.*

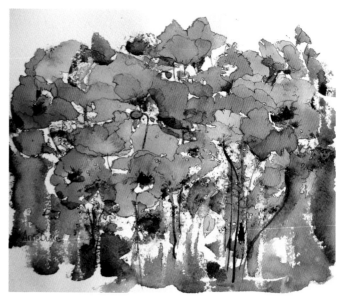

Jamboree, 2010. 10" x 12", watercolor painting. *Photo courtesy of the artist*

Lubna Zahid

Reston, Virginia, United States

I have always been inspired by nature, and love to capture its beauty in these two media. I am specially fascinated by the colors and delicacy of flowers, and the way the light falls and shines through them creating shadows and movement.

My media are watercolor and silk painting. I find painting on silk to be quite similar to painting on watercolor paper. Both media allow for a certain type of wondrous fluidity and animation which is exciting but unpredictable. After years of experimenting I have become less keen as an artist to tame these media and have instead grown to cherish their caprice.

WEBSITE: www.elzyart.com

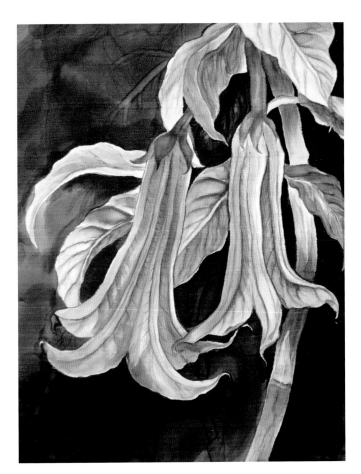

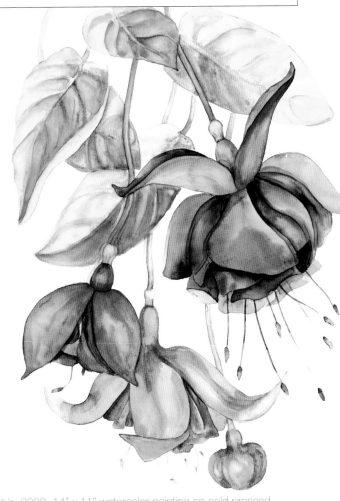

Datura, 2011. 16" x 20", silk painting on Habotai silk, mounted on canvas. *Photo courtesy of the artist.*

Fuschia, 2009. 14" x 11", watercolor painting on cold pressed Fabriano paper. *Photo courtesy of the artist.*

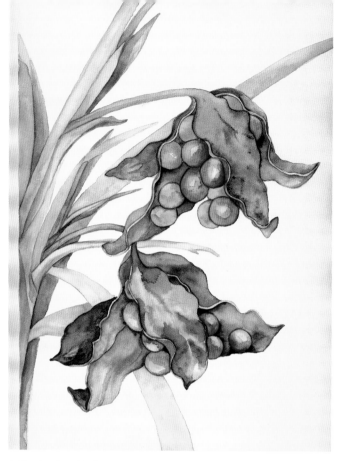

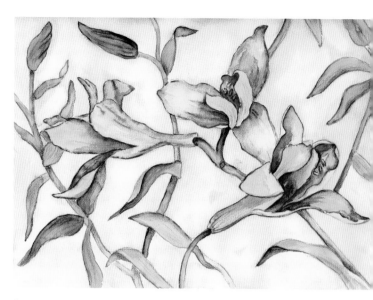

Sunshine Beauty, 2009. 14" x 11", watercolor painting on cold pressed Fabriano paper. *Photo courtesy of the artist.*

A Study of an Iris Pod, 2009. 14" x 11", watercolor painting on cold pressed Fabriano paper. *Photo courtesy of the artist.*

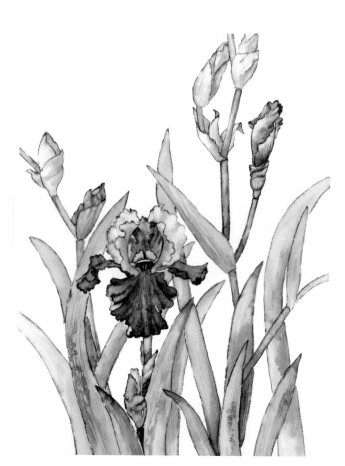

Study of an Iris, 2009. 14" x 11", watercolor painting on cold pressed Fabriano paper. *Photo courtesy of the artist.*

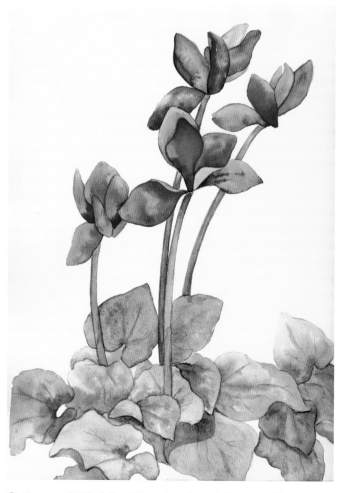

Cyclamens, 2009. 14" x 11", watercolor painting on cold pressed Fabriano paper. *Photo courtesy of the artist.*

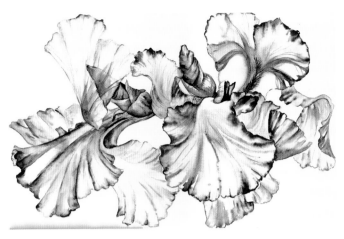

Dance in the Wind, 2009. 14" x 11", watercolor painting on cold pressed Fabriano paper. *Photo courtesy of the artist.*

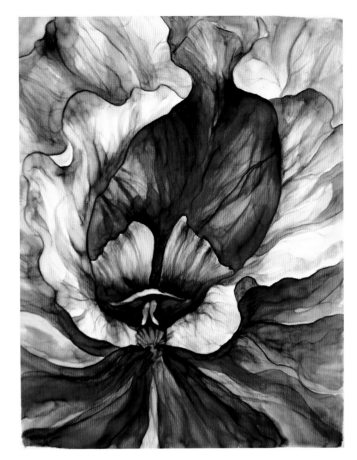

Iris in Bloom, 2009. 20" x 16", silk painting on Habotai silk, mounted on canvas. *Photo courtesy of the artist.*

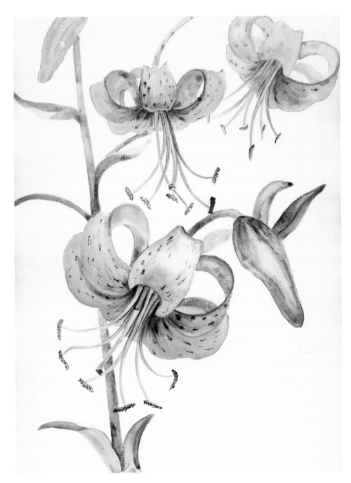

Asiatic Lily, 2009. 14" x 11", watercolor painting on cold pressed Fabriano paper. *Photo courtesy of the artist.*

Tulips, 2009. 14" x 11", watercolor painting on cold pressed Fabriano paper. *Photo courtesy of the artist.*

Sheree Nelson

Great Falls, Montana, United States

Until recently, I had been a floral designer for 12 years. Creating a floral arrangement was an extension in a 3-D version of my paintings! I always wanted the customer to leave the store with a piece of art, not just a bouquet. When I decided to pursue my art career, painting my floral designs seemed like an obvious choice! Someone had made the comment, "Your floral designs are just like your paintings!"

In my paintings, as with my approach to my flower arrangements, I start with my focal flower and move outward. I like to use color; I want people to see the beauty of flowers in real time, not held back! Once I have completed the rendering of flowers, I go back and outline everything in black. The black outline is key in almost every one of my paintings. It is the containment to worldly and regular daily chaos. The great bonus about painting floral arrangements... the flowers stay where I paint them, and they can never wither, just as bright and just as fresh as new!

WEBSITE: www.shereenelsonart.com

Gerbs On Blue, 2009. 20" x 16", acrylic painting.
Photo courtesy of the artist.

Ginger and Orchids, 2009. 20" x 16", acrylic painting.
Photo courtesy of the artist.

Stargazer and Iris, 2011. 20" x 16", acrylic painting.
Photo courtesy of the artist.

Orchids On Aqua, 2009. 20" x 16", acrylic painting.
Photo courtesy of the artist.

John Holicka

Chicago, Illinois, United States

Since I acquired my first macro lens, I have been fascinated by the inner beauty of flowers; a beauty that the naked eye fails to see upon a casual glance. The spectacular manner in which these flowers draw attention to themselves, in hopes of attracting pollinators, is varied and quite amazing. My technique is simple. I often attempt to position my lens inside the petals, way closer than I should be, and start snapping away. Sometimes the results are surprising, and reveal this "hidden world" to the photographer. The beauty of digital photography is that I can take endless shots of the same subject, and then sort through them to see what unknown details a picture might bring to light. It's exciting to me to see what Mother Nature has produced and to be able to capture and preserve its beauty forever through photos.

WEBSITE:
www.JohnHolickaPhotography.com

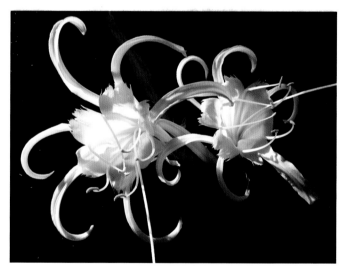

Pinwheel/Lily, 2011. 8.5" x 11", photograph.
Photo courtesy of the artist.

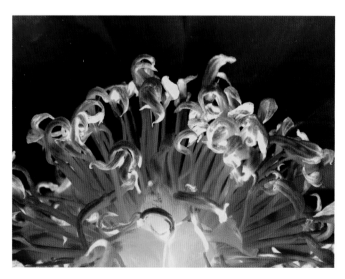

Radiant Beauty/Peony, 2010. 8.5" x 11", photograph, digital color enhancement. Photo courtesy of the artist.

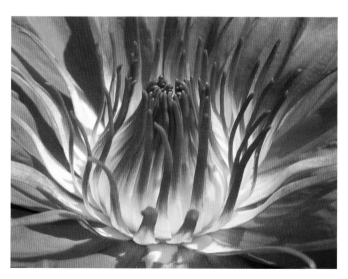

Inner Glow/Water Lily, 2011. 8.5" x 11", photograph.
Photo courtesy of the artist.

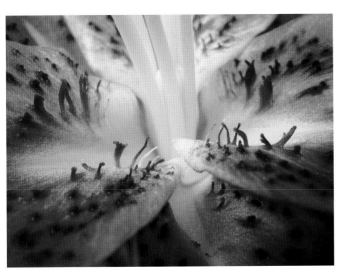

Sea Anemones/Lily, 2011. 8.5" x 11", photograph.
Photo courtesy of the artist.

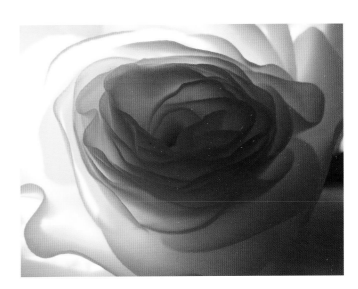

Glowing Begonia, 2011. 8.5" x 11", photograph.
Photo courtesy of the artist.

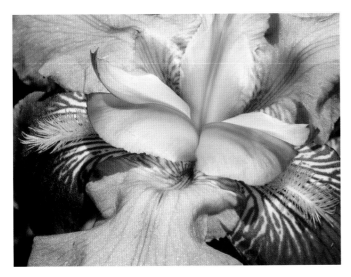

Soft Beauty/Iris, 2011. 8.5" x 11", photograph.
Photo courtesy of the artist.

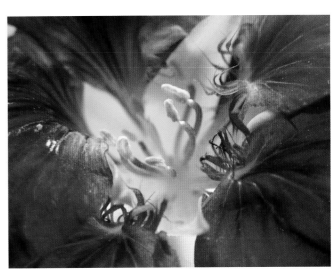

Chaotic Beauty/Nasturtium, 2011. 8.5" x 11", photograph.
Photo courtesy of the artist.

Ashley E. Cooke

Annapolis, Maryland, United States

When I was younger, I wondered whether or not people would ever see what I saw. I believed they wouldn't; I hesitated in sharing with anyone what I did see. I was afraid; different was bad. It took a lifetime to figure out that being "different" and seeing "different" is a gift, just as creativity is a gift. Gifts are meant to be shared and what I have discovered is that bringing creativity and discovery into the lives of others is the best gift of all. So, here I am. I give you what I see through the lens of my camera. I photograph orchids (the obvious) and I have discovered beings (my Orchid Aliens) that I see living within the orchids (the less obvious).

Do you see what I see? I'm interested in what you see. So many others have exercised their creativity, seen other worldly beings within my photographs, and shared what they've seen with others. I hope that you have as much fun seeing the less obvious life within the more obvious one as I do! What will you do? Keep it to yourself for fear of being different; or share with a friend the wonders and beauty of creative dialogue, sharing perspectives on your own Orchid Alien discoveries.

WEBSITE: www.redbubble.com/people/cookeadr2003

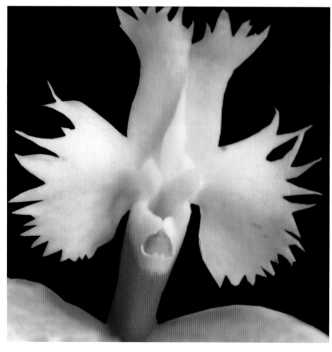

Beaker, 2011. 8"x 10", digital photograph.
Photo courtesy of the artist.

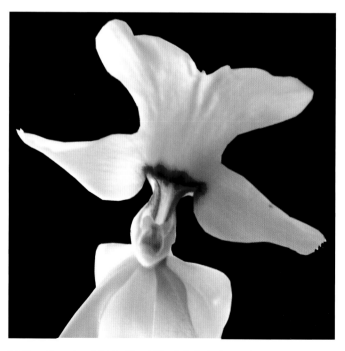

Mother Superior, 2011. 8" x 10", digital photograph.
Photo courtesy of the artist.

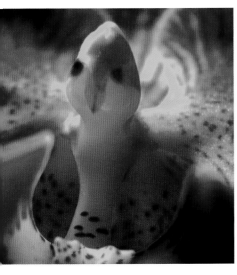

Lucky, 2010. 8" x 10", digital photograph. *Photo courtesy of the artist.*

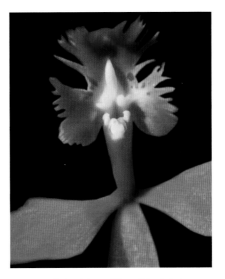

Rooster Tale, 2011. 8" x 10", digital photograph. *Photo courtesy of the artist.*

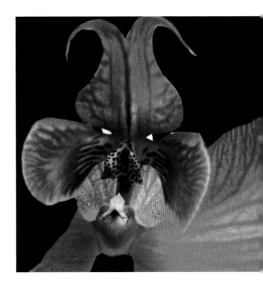

Shep, 2011. 8" x 10", digital photograph. *Photo courtesy of the artist.*

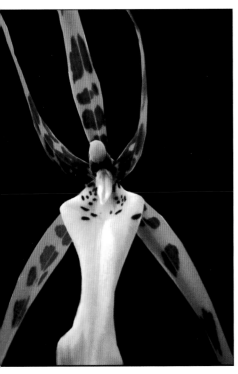

Slim Slam, 2010. 8" x 10", digital photograph. *Photo courtesy of the artist.*

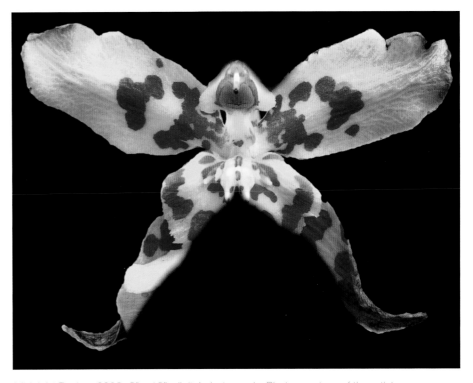

Midnight Rodeo, 2009. 8" x 10", digital photograph. *Photo courtesy of the artist.*

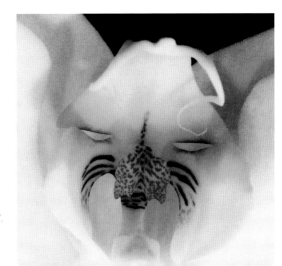

Tom, 2010. 8" x 10", digital photograph. *Photo courtesy of the artist.*

Susan La Mont

McLean, Virginia, United States

Flowers are the classic, eternal symbol of beauty. I can't resist outdoor flower markets, whether they are in a city or a farmers' market setting, and the sight of daffodils in spring always seems like a reward for enduring the harshness of winter. I try to surround myself with them as much as possible, whether it's a baker's rack full of dainty African violets in the house, or a bowl of fluffy double pink petunias out on the porch. Flowers always lift my spirits!

WEBSITE: www.susanlamont.com

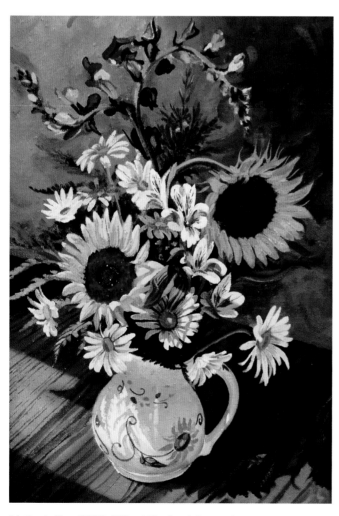

Mother's Day, 2002. 20" x 14", oil painting on linen.
Photo courtesy of the artist.

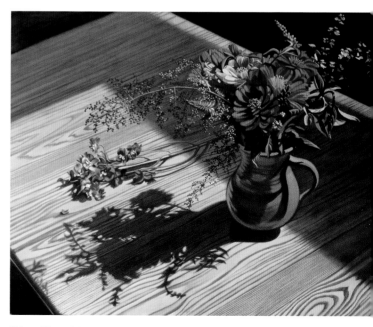

Prime Time, 2011. 40" x 50", oil painting on linen.
Photo courtesy of the artist.

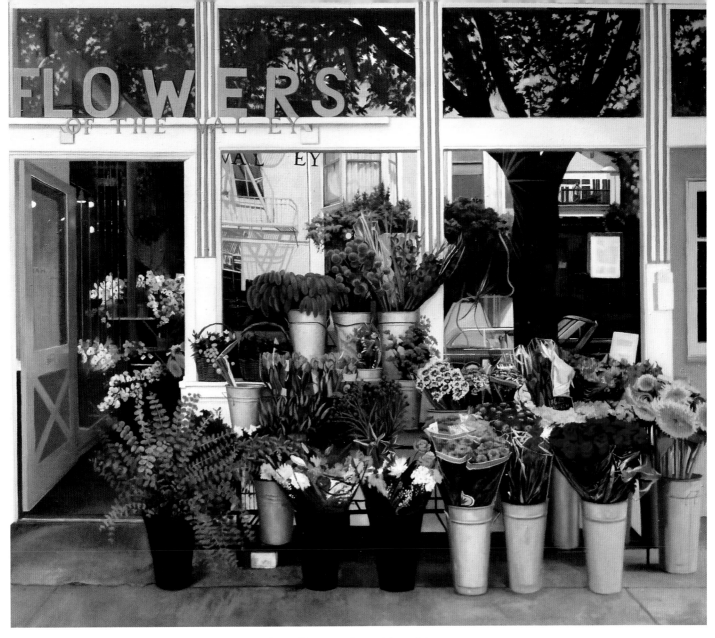

Flowers of the Valley, 2008. 48" x 54", oil painting on linen. *Photo courtesy of the artist.*

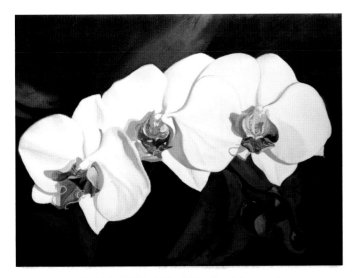

Three White Orchids, 2008. 12" x 16", oil painting on linen.
Photo courtesy of the artist.

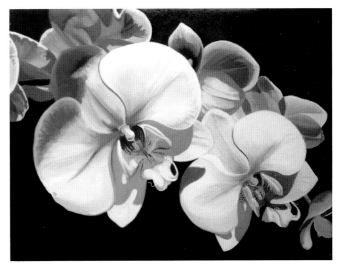

Orchids in Light and Shadow, 2008. 12" x 16", oil painting on linen.
Photo courtesy of the artist.

Emily Galusha

Austin, Texas, United States

"Keep your love of nature, for that is the true way to understand art more and more." –Vincent Van Gogh.

The genius in God's creation is both alarming and fascinating. My artwork displays the study of herbs and wildflowers, attending to the beauty of each vein and petal. The illustrations are executed in pen to give fine detail, and the colored pencil enriches the visual imagery.

WEBSITE: www.eegcreative.com

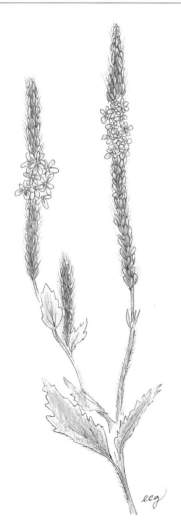

Verbena, 2010. 7" x 3" (unframed), colored pencil and ink. *Photo courtesy of the artist.*

Goldenrod, 2010. 7" x 4.5" (unframed), colored pencil and ink. *Photo courtesy of the artist.*

Lauren Dunning

Portage, Indiana, United States

My paintings start with a renewed realization of the natural beauty that exists. In my work, I want to show the excitement and happiness that I receive when I sit down and draw the natural construction of plants through ink and gouache. In doing this, I hope that my viewers will not see my paintings as simple flowers, but as an expression of the joy nature inspires in me.

To express the bright natural environment, I choose vibrant colors of gouache and black ink for contrast. With gouache I feel that I am capable of creating a loose, airy quality. With the ink, I make quick, sketchy lines that add shape and emphasis, and give my work to have a loose, rendered look. With this style, my hope viewers will be intrigued by my work and will want to come in for a closer look as well as go out and enjoy nature the way I do.

WEBSITE: www.lmd-studios.com

Flowering Crab, 2011. 8" x 10", gouache and ink painting.
Photo courtesy of the artist.

Daisies, 2010. 10" x 8", gouache and ink painting.
Photo courtesy of the artist.

Lilies, 2010. 8" x 10", gouache and ink painting. *Photo courtesy of the artist.*

Orchid, 2011. 10" x 8", gouache, ink painting, and paper.
Photo courtesy of the artist.

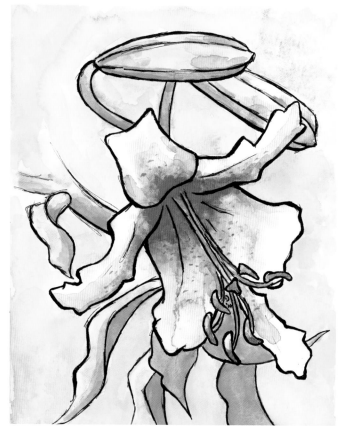

Lily, 2010. 10" x 8", gouache and ink painting.
Photo courtesy of the artist.

L. W. Morris

Midpines, California, United States

Flowers are the eternal truth of life. They are here with us year round. They inspire every emotion on this planet, and they are used to make this world's vast numbers of products smell better. Not to mention the vast number of medications and poisons that comes from them. This one simple thing called a flower comes in such a vast variety that you could spend your entire life and never even come within an ocean of seeing them all.

Flowers arrive when you are brought into this world, and are given again to send you out of it. They are given as gifts and used as ornaments in everyday life. They represent love and, yes, even hate. We use them at every special occasion during our lifetimes. Flowers and their arrangement have always been in my life from the earliest of my recollections. I draw so many different things from horses and Western Americana, to the human figure, landscapes, wildlife, birds, and still life. Nothing can ever pull me out of an artist block except for floral art. They always inspire me to work. I was raised with flower gardens around our home my entire life. My grandparents had them, and the rest of my extended family also. Flowers are always going to be like coming home to me.

WEBSITE: www.lwmorrisjr.deviantart.com

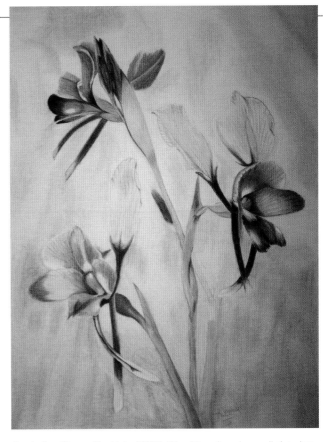

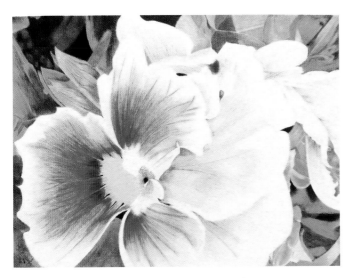

Blue Pansy, 2011, 12" x 9", colored pencil drawing.
Photo courtesy of the artist.

Australian Pansy Orchids, 2009. 9" x 1", colored pencil drawing.
Photo courtesy of the artist.

Pamela Casey

Jacksonville Beach, Florida, United States

I'm blessed to live near the Atlantic Ocean, the St. John's River, the intracoastal waterway, and a thriving marsh. I'm literally surrounded by nature's beauty from sunrise to sunset. Inspiration is everywhere. I just can't help taking pictures of it. I love it all, as well as the furry, feathered, and finned creatures that inhabit these places; well, maybe not sharks or eels or man-o-wars.

I have been taking photos for more than 40 years. So, I begin with photography, but I seek to find more than just a pretty picture. I want you to see what I see through the lens: a familiar subject revealed in a new way. Flowers are one of my favorite subjects. I enjoy using digital and traditional artistic tools to find something you may not see to begin with, to dig a little deeper, to change the image. I hope to enrich the vision and perception of anyone who shares my world by looking at my images. That's the joy of the creative journey for me. Come along for the ride!

WEBSITE: www.pamelacasey.com

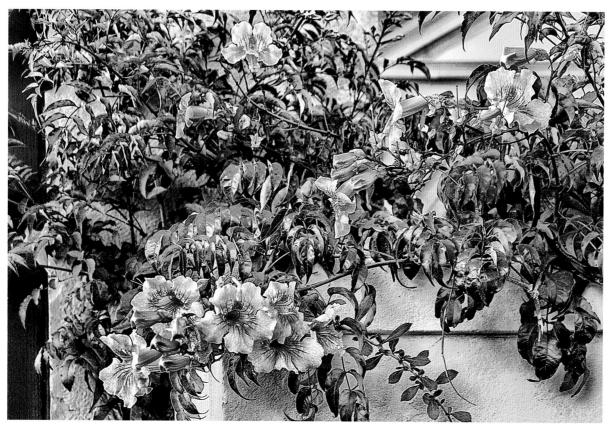

Sound the Pink Trumpets, 2011. 20" x 16", photographic impression. *Photo courtesy of the artist.*

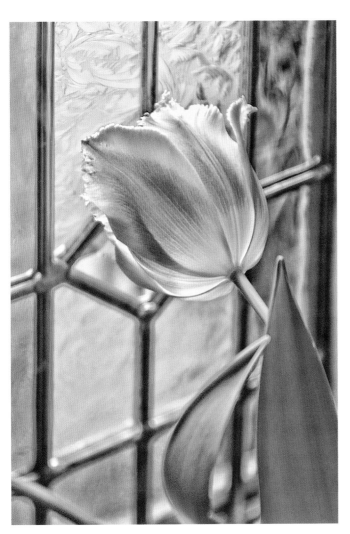

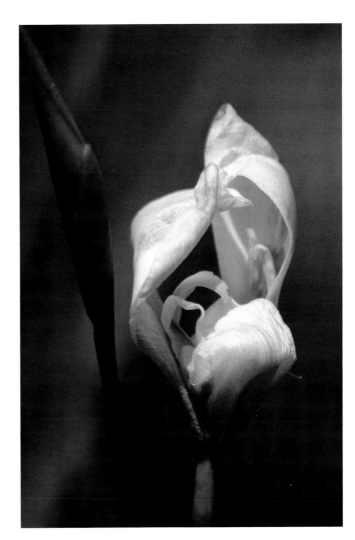

Waiting for Godot, 2008. 16" x 20", photographic impression.
Photo courtesy of the artist.

New Life, 2010. 14" x 11", photograph.
Photo courtesy of the artist.

Ann Sperling

Mission Viejo, California, United States

As an artist, I enjoy photographing many things. I never set out to photograph flowers, but when I see them, I am in awe of their beauty and want to capture their magnificence. Almost everywhere I go I see flowers and other things in nature, and I am drawn to them. I am a gardener as well as being an artist. Because I tend my own garden and appreciate it on a daily basis, I take notice of flowers I might encounter outside of a building, and appreciate them instead of just walking by. Many of my photographs are macro photographs, capturing things at very close range, and I like using this technique to see flowers in an almost abstract way.

I am drawn to color first, because of my love of it, and then take in the other elements of design that make up the flowers and their surroundings. To me there is a lot of symbolism and something to learn from the cycle of life of flowers; we can see more easily and in a shorter period of time, the bud, the bloom, and the death as compared to the cycle of our own lives. The way any artist sees color, perceives things, or expresses how she feels about things is a gift, and we are obligated to share our vision with the world through painting, sculpture, photography, etc. The artist holds up a looking glass to another way of looking at the world, or in the case of "stopping to smell the roses," she holds up a looking glass to viewing with appreciation and bowing to the majesty that surrounds us.

WEBSITE: www.annfanciullosperling.com

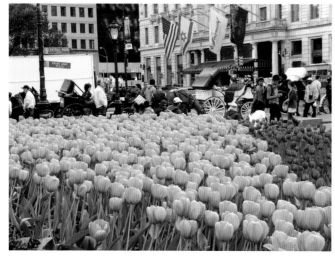

Central Park Tulips, 2010. 16" x 24", photograph.
Photo courtesy of the artist.

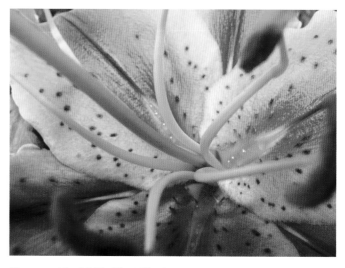

Stargazer Lily, 2008. 8" x 12", photograph.
Photo courtesy of the artist.

Flower within a Flower, 2011. 16" x 24", photograph.
Photo courtesy of the artist.

Sea Lavender, 2009. 8" x 12", photograph.
Photo courtesy of the artist.

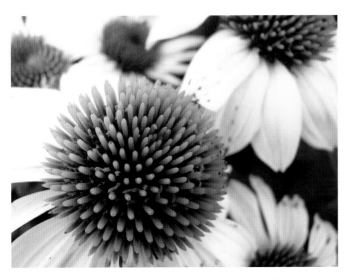

Burst, 2011. 16" x 24", photograph. *Photo courtesy of the artist.*

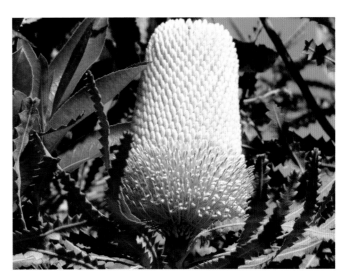

Cone, 2011. 16" x 24", photograph. *Photo courtesy of the artist.*

Double Delight, 2011. 16" x 24", photograph.
Photo courtesy of the artist.

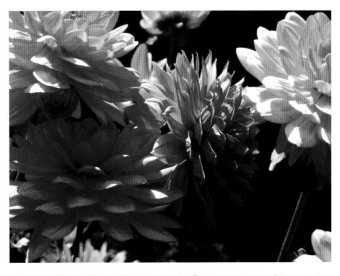

Dance, 2011. 16" x 24", photograph. *Photo courtesy of the artist.*

Anne Elise Pemberton

Bethesda, Maryland, United States

Nature has always been a major source of inspiration in my artwork. Each flower expresses its own personality, and can be either stimulating or calming. Being surrounded by hundreds of sunflowers or lotus blossoms, and being able to capture the moment, is an unforgettable experience.

The different types of light striking the flowers enhance their subtle characteristics. All the refined editing techniques offered by digital photography enable me to layer and blend images, and I often print my photos on vellum, watercolor paper, or glass.

WEBSITE: www.anne-elise-art.com

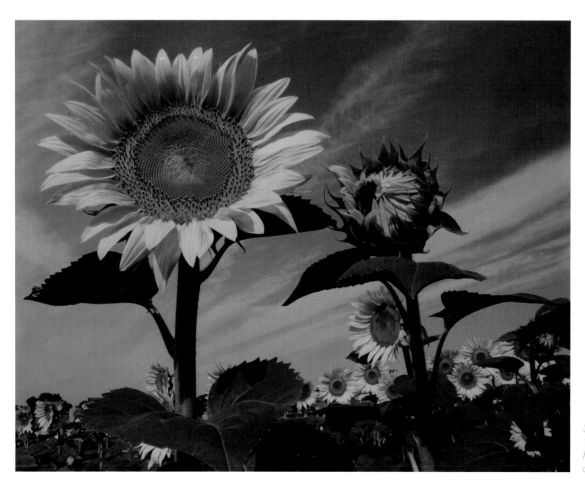

Sunflowers, 2009. 12" x 15", digital photograph. *Photo courtesy of the artist.*

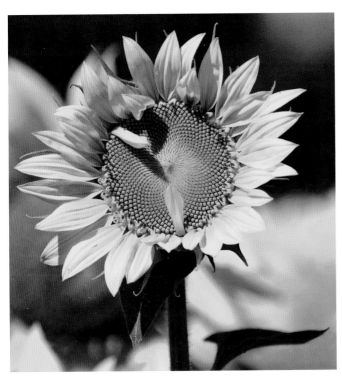

Sunflower, 2011. 11" x 12", digital photograph.
Photo courtesy of the artist.

Sunflower, 2011. 18" x 12",digital photograph.
Photo courtesy of the artist.

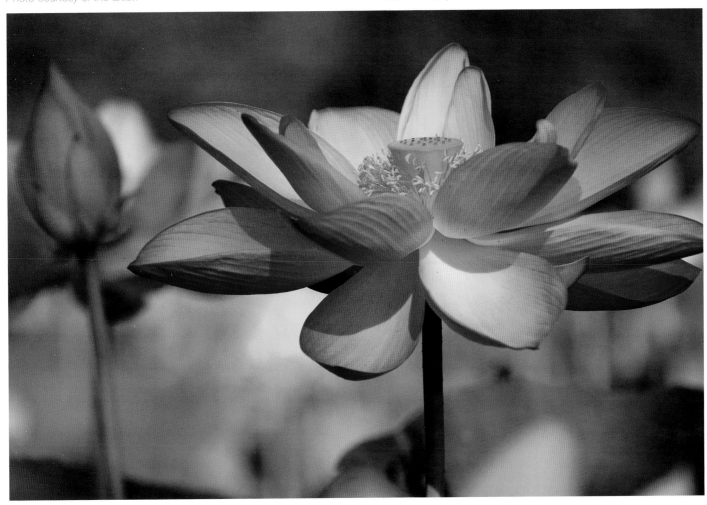

Lotus Flowers, 2011. 6.5" x 9.5", digital photograph. *Photo courtesy of the artist.*

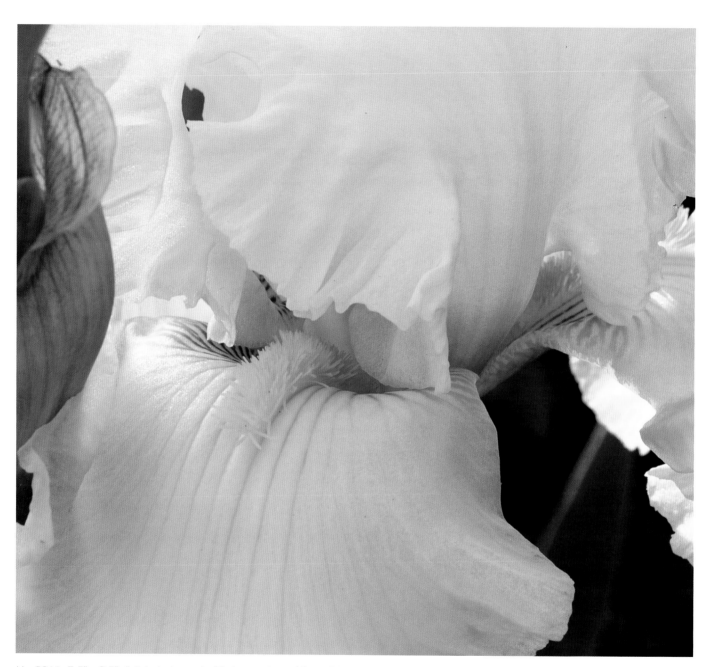

Iris, 2011. 7.5" x 8.5", digital photograph. *Photo courtesy of the artist.*

Cleome, 2009. 4" x 5.5", digital photograph. *Photo courtesy of the artist.*

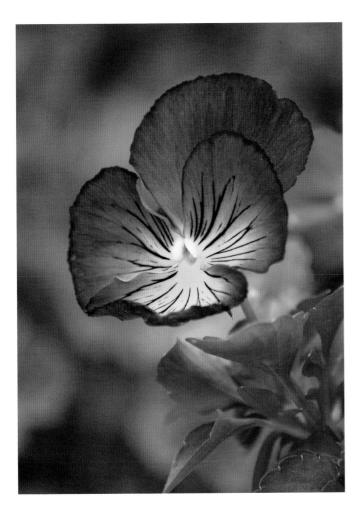

Pansy, 2010. 9" x 6.5", digital photograph.
Photo courtesy of the artist.

Lillies, 2009. 10" x 18", digital photographs, multiple exposures.
Photo courtesy of the artist.

Maryann Goodhue

Montgomery, Alabama, United States

Blessed to grow up in the Garden State, surrounded by parks devoted to flowers and fragrant trees, it has provided me a lifetime of appreciation of floral design. Now as I paint my floral oils, I think about the days I walked in the Iris Garden Park with my grandmother, picking violets for May Day baskets and the many hours spent with my mother in our backyard rose garden. I love to paint the gradual changes of hues found in flowers, I'm fascinated with the patterns and textures found in nature using these elements in my oil paintings. Since moving to the south I find myself inspired by the magnificent floral trees and charmed by my garden again.

WEBSITE: www.maryanngoodhue.fineartstudioonline.com

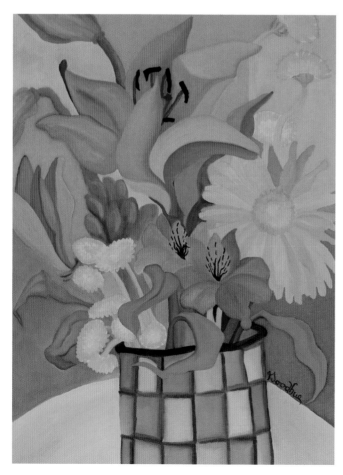

Summer Lily, 2010. 24" x 18", oil on canvas.
Photo courtesy of the artist.

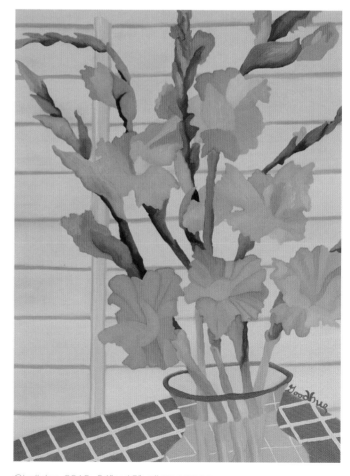

Gladiolas, 2010. 24" x 18", oil on canvas.
Photo courtesy of the artist.

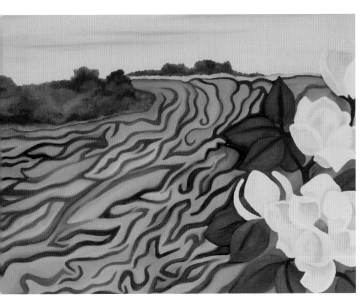

Alabama River Magnolia, 2010. 24" x 18", oil on canvas. *Photo courtesy of the artist.*

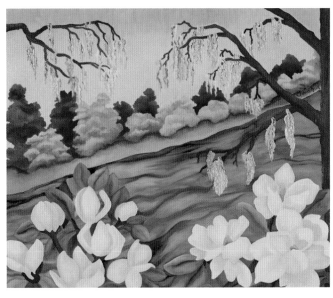

Alabama River, 2009. 24" x 18", oil on canvas. *Photo courtesy of the artist.*

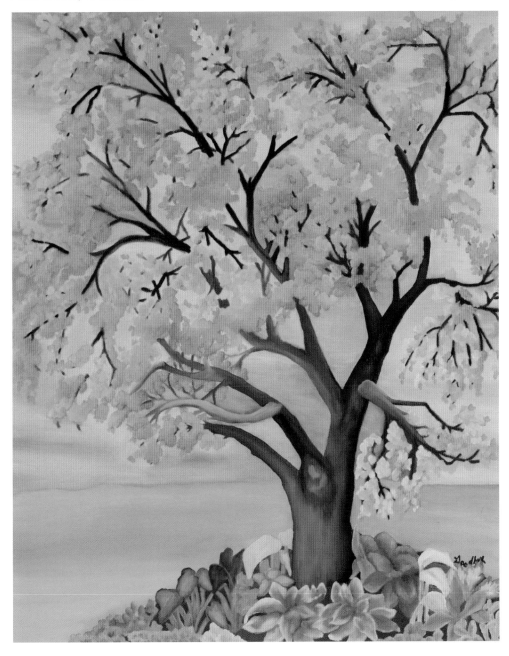

Mock Peach, 2007. 30" x 24", oil on canvas. *Photo courtesy of the artist.*

Megan Coyle

Alexandria, Virginia, United States

My art work involves the style of "painting with paper," a collage technique whereby I recreate the look and feel of a painting through the manipulation of magazine strips. Utilizing this method allows me to create artwork that captures the essence of a painting, but broadens my palette to include textures, patterns, and fragments of photographs from magazines.

Collage is my preferred medium because of its versatility. I can build up an image's surface by layering different shapes of paper and I can peel away pieces to let previous layers shine through. By intricately layering and cutting paper, I can focus in on the details of the subjects I collage. I am interested in creating representational art, artwork that viewers can relate to and that reminds them of memories associated with everyday scenes and objects. I like depicting flowers and gardens as well as portraits, animals, and landscapes because they make us think about the world around us. While depicting flowers, I find myself breaking down the details I see into fragments, piecing together my collages bit by bit, occasionally stepping back to see the work in its entirety.

WEBSITE: www.mcoyle.com

Autumn Flowers, 2009. 7" x 5", collage from magazine strips. *Photo courtesy of the artist.*

Daffodils, 2004. 16" x 20", collage from magazine strips and oil pastel. *Photo courtesy of the artist.*

Pink Flowers, 2008. 9" x 12", collage from magazine strips.
Photo courtesy of the artist.

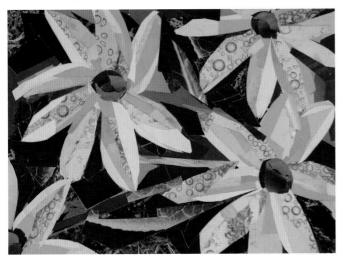

Yellow Flowers, 2009. 5" x 7", collage from magazine strips.
Photo courtesy of the artist.

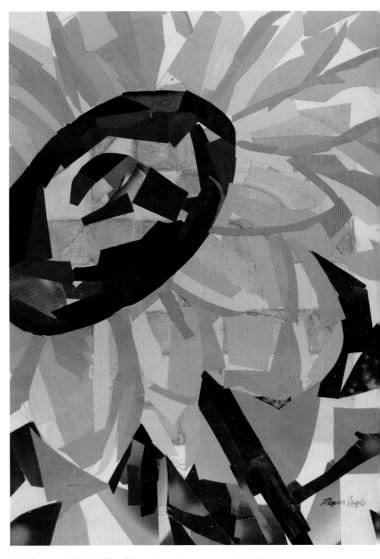

Sunflower, 2008. 12" x 9", collage from magazine strips
and watercolor. *Photo courtesy of the artist.*

In the Garden, 2008. 12" x 16",
collage from magazine strips and oil
pastel. *Photo courtesy of the artist.*

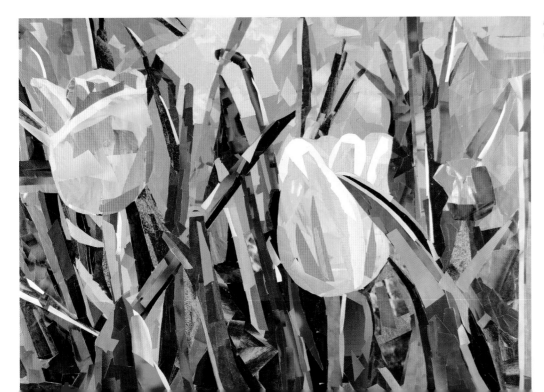

Ning Fan

Fairfax, Virginia, United States

Flowers present a whole world for us to explore. We see colors, shapes, texture; we see the individual details with macro lenses; we see them color the mountains and plains with wide-angle lenses; we admire the delicacy; we are in awe of the endless variety. Flowers consistently provide inspiration to me. As a photographer, I pay special attention to the conditions that are able to reveal the intrinsic beauty of flowers: I work with the light; I work with the wind; I strive to give the viewers of my photos an opportunity to further explore.

For the wisteria photos, I chose to shoot outdoors, capturing the free flowing grace of the blossoms. I chose to shoot against the sun, revealing the petals' transparency and delicacy. The orchids were shot in the US Botanic Garden in Washington, DC. My emphasis was on making sure the entire image surface serves the purpose of expressing certain feelings. That would require the photographer to pay great attention to the background, the background colors, the choice of depth of field, and the overall composition in addition to the main subject. To me, flower art is more than merely recording the flower, it is the artist engaging all the elements in the view finder to serve the single purpose of expression.

WEBSITE: www.ningfanphoto.com

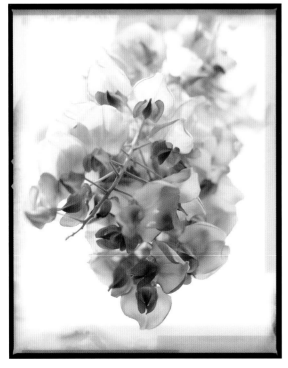

Wisteria I, 2011. 10" x 8", photograph.
Photo courtesy of the artist.

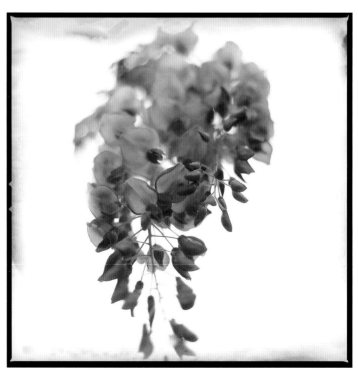

Wisteria III, 2011. 10" x 10", photograph.
Photo courtesy of the artist.

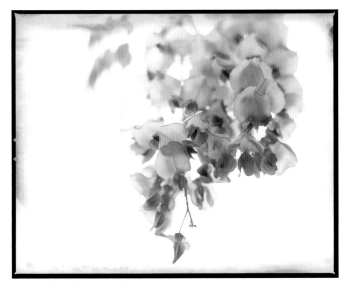

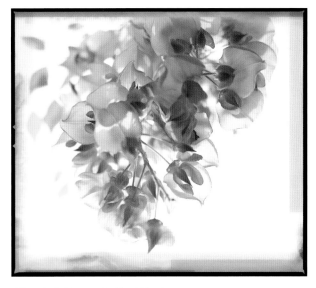

Wisteria IV, 2011. 8" x 10", photograph.
Photo courtesy of the artist.

Wisteria II, 2011. 10.5" x 12", photograph.
Photo courtesy of the artist.

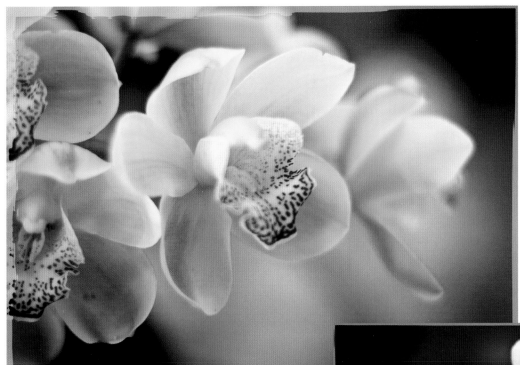

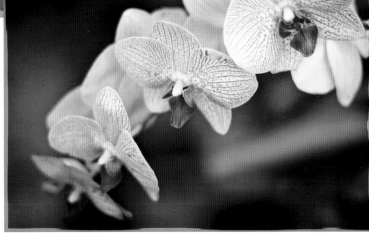

Orchid II, 2011. 10" x 14", photograph.
Photo courtesy of the artist.

Orchid VI, 2011. 10" x 14"", photograph. *Photo courtesy of the artist.*

Jessica Stelling

Savannah, Georgia, United States

I call this body of work Nature's Haiku. I find them to be serene meditations of simple beauty – a quiet poetry that waits to be noticed and given life. Each is a perfection all its own. Whether it be the fold of two leaves so tender, or a blushing contrast ring of yellow against fuchsia, they somehow become emotional testaments that offer secrets about a world we don't always understand but comprehend through feeling.

These detail shots are made with my digital SLR equipped with a Lensbaby Macro Lens. They are soft, selected focus and dreamy but saturated in color.

WEBSITE: www.stellingphotographics.com

Flower Study 0004, 2011. 9" x 12", photograph, C-print. *Photo courtesy of the artist.*

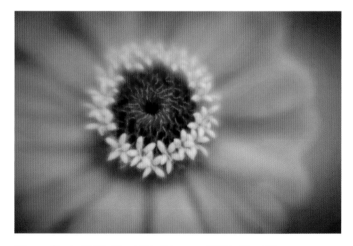

Flower Study 2506: The Little Princess, 2011. 9" x 12", photograph, C-print. *Photo courtesy of the artist.*

Eleanor Leonne Bennett

Manchester, Cheshire, England

I really enjoy taking floral photography and creating mixed media. When taking photos, composition is key in my mind. I like my photos to be pleasing to the eye; I like to create pictures that work with the mind. Everybody knows that when they look at their favorite photographs something is key to the construction; delete one feature and it could never be the same. My mixed media works using flower parts have won me first place in the Nature Detectives Contest three times since the age of 11. All of my family enjoy planting flowers and trees and my village of Disley in Cheshire, which has won awards for its beautiful gardens.

Creating a garden adds to conserving the wider environment. It is very important for biodiversity and ecological variety.

WEBSITE: www.eleanorleonnebennett.zenfolio.com

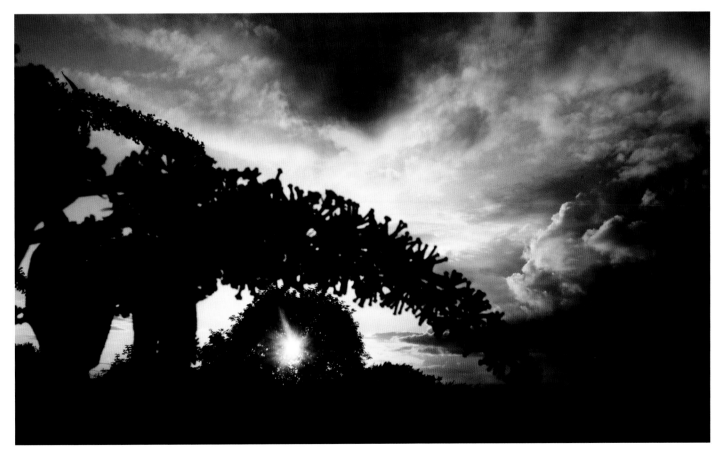

Elderflower Sunset, 2010. 15" x 26", photograph. *Photo courtesy of the artist.*

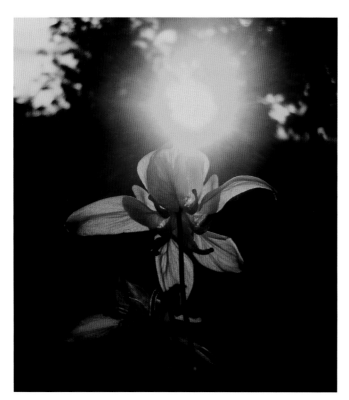

April Radiance, 2009. 12" x 13", photograph.
Photo courtesy of the artist.

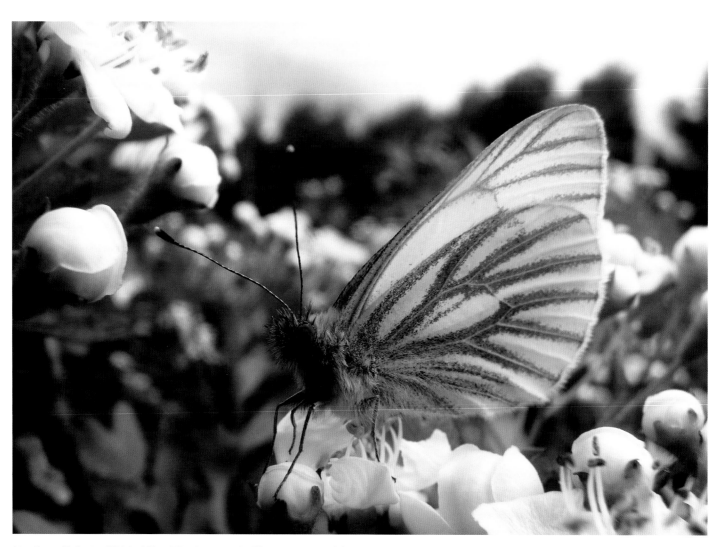

Hawthorn Delicate, 2011. 13" x 18", photograph. *Photo courtesy of the artist.*

Ida
Pettersson

Pyhtää, Finland

I love flowers. They are so gorgeous that I just can't just let them be without taking photos of them. I get thrilled with nature in general, so it is very easy to just take the camera and go take photographs of flowers and nature. I do try to make the flowers interesting so it's not just another photo of a flower. I hope to get the viewer to look at the photo and think how it has been done or at least be a little amazed by just the beauty of the flower. I used a few different optics on my camera to create these photos and the light on all of them is just the available light.

WEBSITE: www.flickr.com/photos/idapett

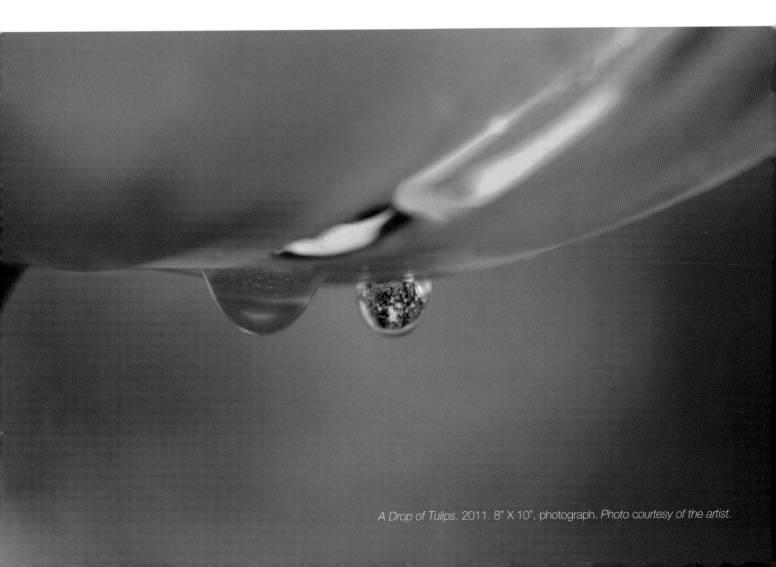

A Drop of Tulips, 2011. 8" X 10", photograph. *Photo courtesy of the artist.*

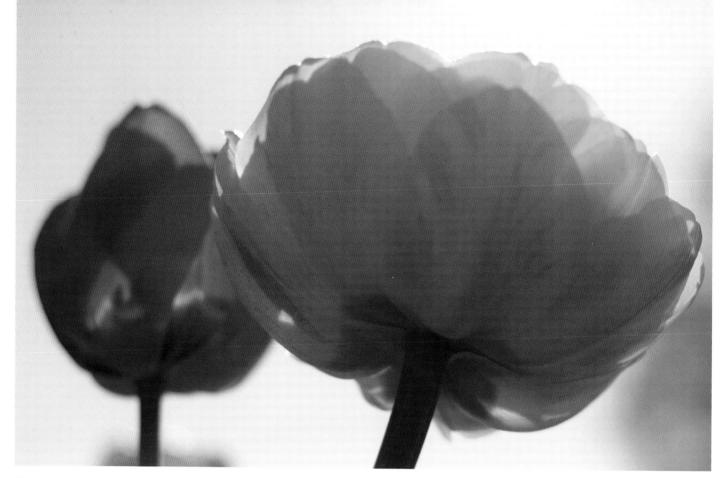

Tulips, 2011. 8" X 10", photograph. *Photo courtesy of the artist.*

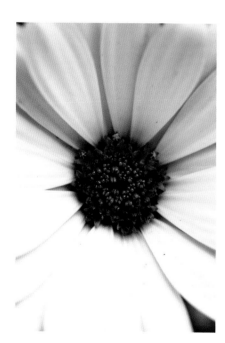

Blue, 2011. 8" X 10", photograph.
Photo courtesy of the artist.

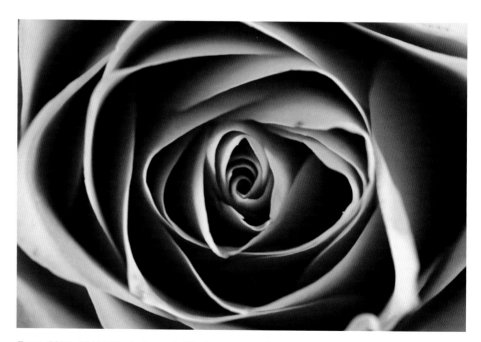

Rose, 2011. 8" X 10", photograph *Photo courtesy of the artist.*

Svetlana Novikova

Cedar Park, Texas, United States

Flowers are one of the most exquisite of God's creations for us to enjoy. They excite our senses; they add pleasure to our existence. They are fresh, spontaneous, fragrant, and beautiful. Flowers are like bursts of the color spectrum around us, and being a colorist, I find them to be an exciting and joyful subject to paint and explore.

WEBSITE: www.SvetlanaNovikova.com

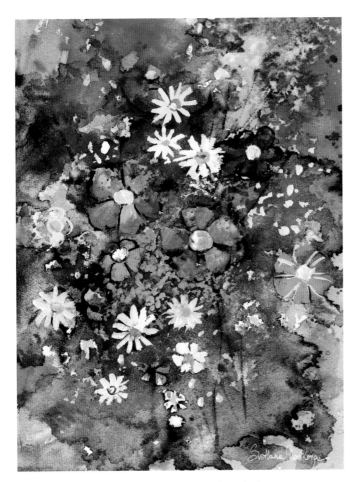

Fantasy Flowers, 2003. 12" x 9", watercolor painting.
Photo courtesy of the artist.

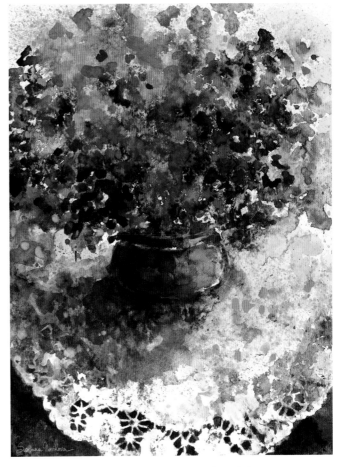

Summer Flowers, 2002. 12" x 9", watercolor painting.
Photo courtesy of the artist.

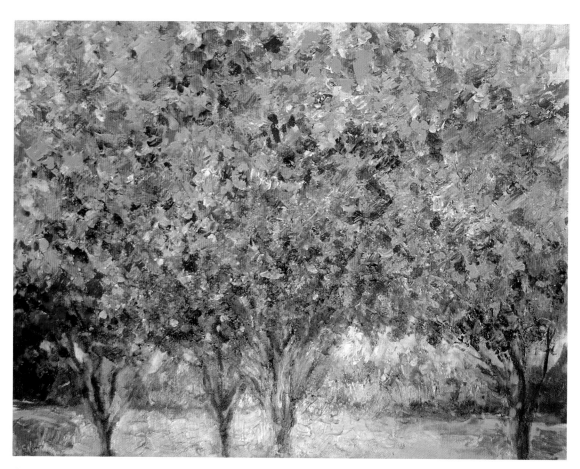

Spring Blossoms, 2006. 24" x 30", acrylic painting. *Photo courtesy of the artist.*

Sandy Byers

Oak Harbor, Washington, United States

Unlike other subjects I paint, I don't paint flowers, they paint themselves in my studio and then they come up with little bits of poetry to go with their art. I always try to make time for them because it is such a joyful process and I just get to sit back and watch.

This is the poetry that came along with the tulips:

One in a Crowd

there is one in a crowd and
you are it.
my day would not
be as bright
without the presence of you.

And, this is the poem that accompanied the roses:

Bold Hearts

delicate petals
give way
to strong, bold hearts.
sun rays
feed the soul.

WEBSITE: www.sandybyers.com

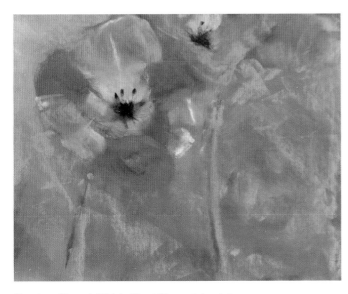

One in a Crowd, 2011. 8" x 10", pastel painting.
Photo courtesy of the artist.

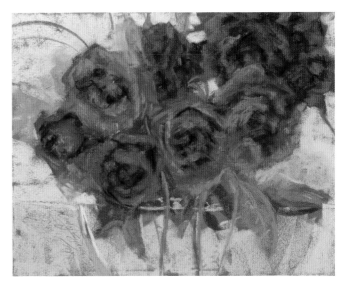

Bold Hearts, 2011. 11" x 14", pastel painting.
Photo courtesy of the artist.

Michael Hilker

Fairfax, Virginia, United States

This series of watercolor studies for my annual calendar was inspired by my vacation to Hawaii. I knew I wanted to somehow capture the lush vegetation, the quality of light, and the movement of light and shadow in the tropical breeze. Many of this series were done on location, where I played with simplifying the shape and color, and experimented with ways of capturing the intensity and contrast of flower to environment. I also used different watercolor techniques of color-run and layering through misting and salt crystals to convey motion and flower structure.

WEBSITE: www.fourcastdesign.com

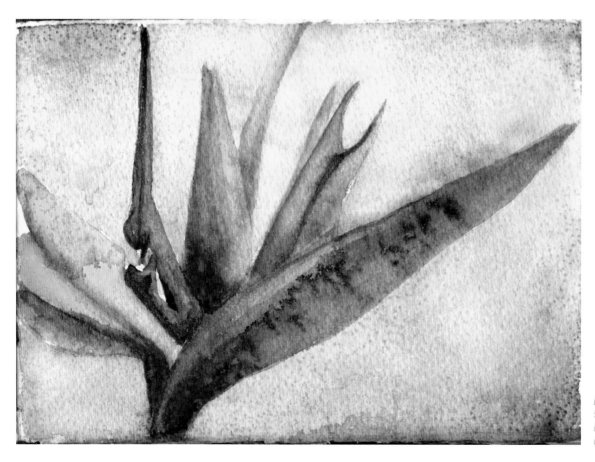

Bird of Paradise, 2010.
5" x 7", watercolor.
*Photo courtesy
of the artist.*

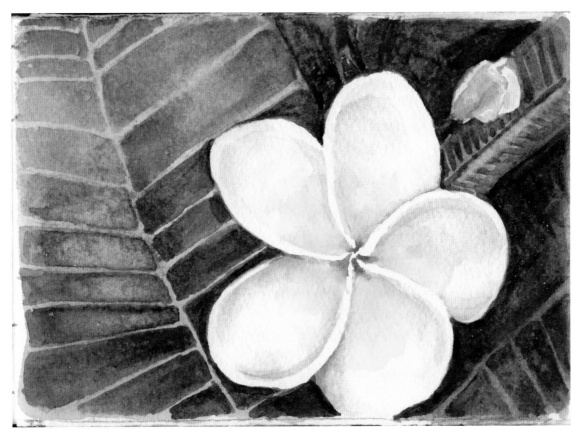

Plumaria, 2010. 5" x 7", watercolor. *Photo courtesy of the artist.*

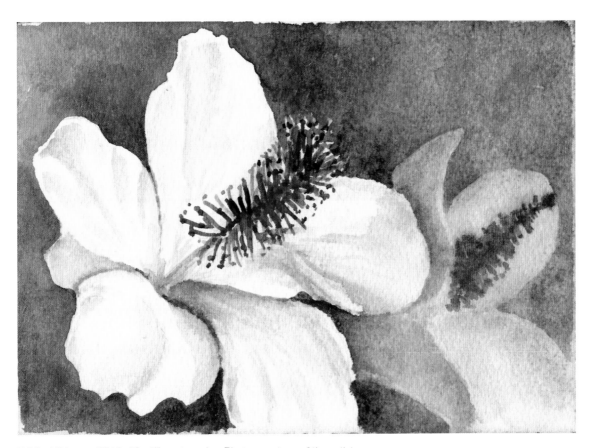

White Hibiscus, 2010. 5" x 7", watercolor. *Photo courtesy of the artist.*

Eldred Boze

Wardensville, West Virginia, United States

Colors and intensity drew me to using flowers as camera subjects. My technique is an attempt to put flowers in a different perspective. I grew dissatisfied with normal blah shots and looked for more drama in my shots. I found myself trying to get an ant's view while crawling on a branch of maraschino cherry blossoms or, in an attempt to create a more "wonderland" world of flowers, I placed irises of various colors in a vase and held them up to the sun. Or I may wish I could put myself into the picture as a climber struggling up the striped leaves only to meet the glaring red-yellow eyes of a witch. As one may guess, I enjoyed the scene from Avatar where giant plants were used as slides.

WEBSITE: www.eldredboze.blogspot.com

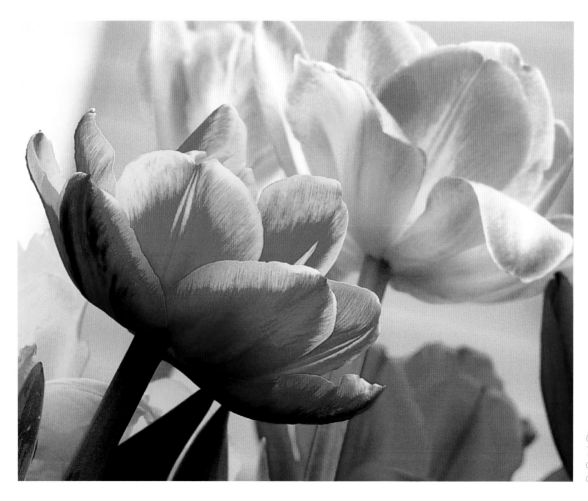

Ground Up View of Tulips, 2000. 8" x 10", digital photograph. *Photo courtesy of the artist.*

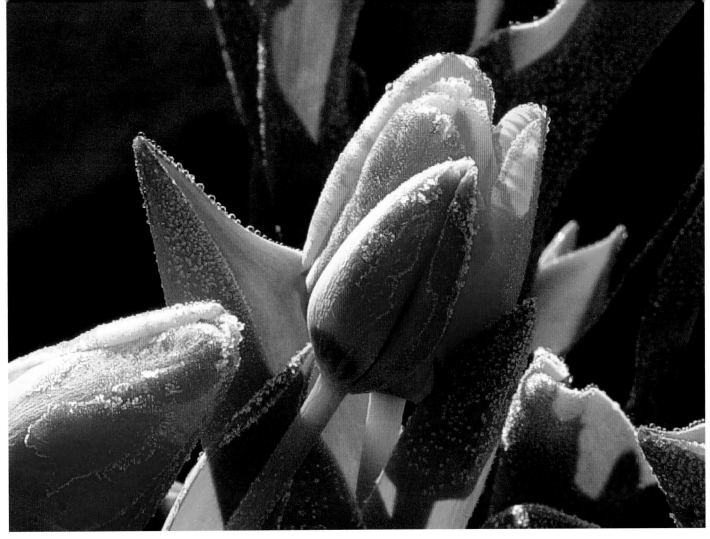

Frost Visits Tulips, 2002. 8" x 10", digital photograph.
Photo courtesy of the artist.

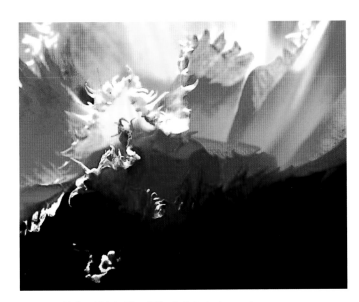

Erupting Tulip, 2004. 8" x 10", digital photograph
Photo courtesy of the artist.

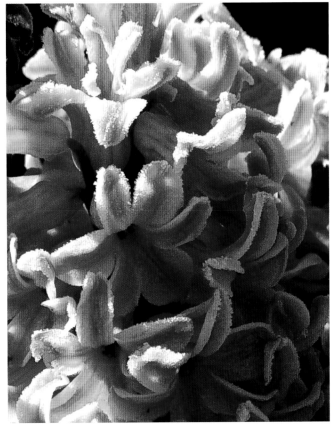

Huddled Hyacinths, 2004. 8" x 10", digital photograph.
Photo courtesy of the artist.

Maraschino Cherry Blossoms, 2009. 8" x 10", digital photograph.
Photo courtesy of the artist.

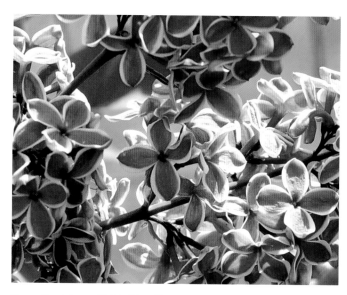

Sensation Lilacs, 2001. 8" x10", digital photograph.
Photo courtesy of the artist.

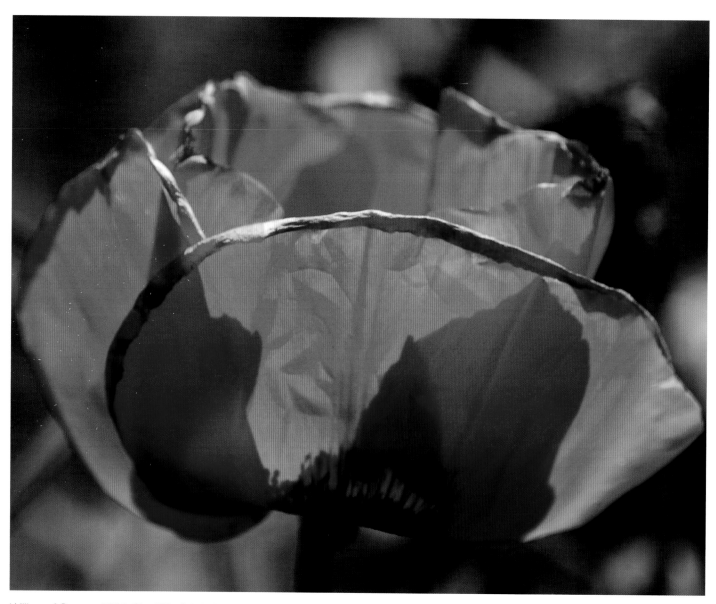

William of Orange, 2004. 8" x 10", digital photograph. *Photo courtesy of the artist.*

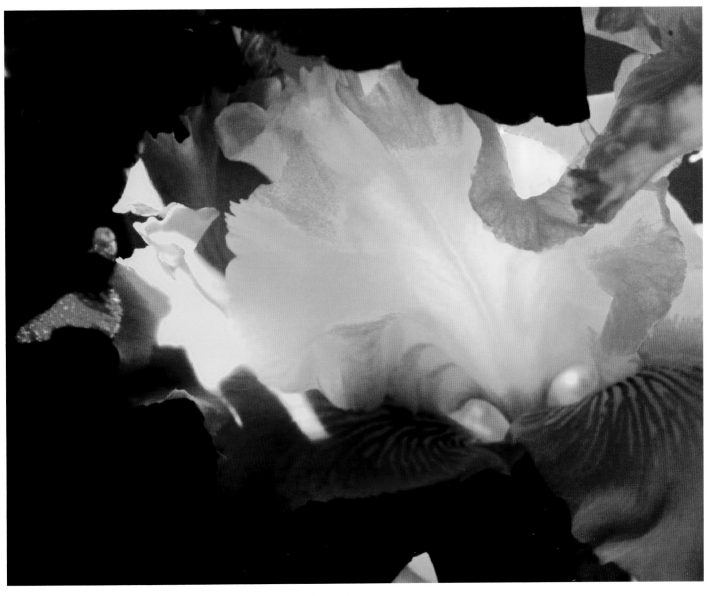

Iris Witch, 2010. 8" x 10", digital photograph. *Photo courtesy of the artist.*

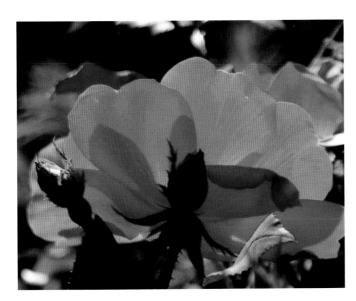

Winery Rose, 2004. 8" x 10", digital photograph.
Photo courtesy of the artist.

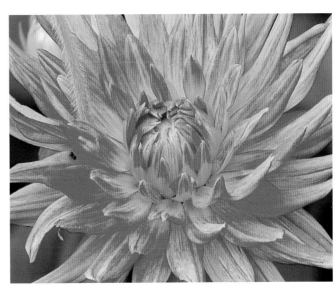

Ant Dahlia, 2004. 8" x 10", digital photograph.
Photo courtesy of the artist.

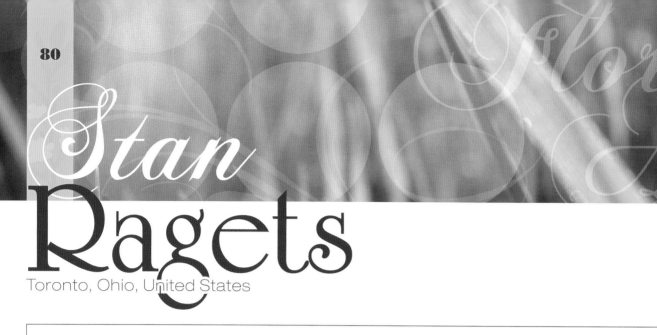

Stan Ragets

Toronto, Ohio, United States

Fractal art as a whole is captivating. The ability to create beautiful art while incorporating the logic of mathematics is incredible. I am constantly inspired by colors, music, and numbers to create new and evolving artwork. Creating and designing flowers by utilizing math is a very exciting process for me. There are endless forms and combinations to make such exciting images. Each piece I work on is never complete until it evokes a strong emotional response from myself and others.

WEBSITE: www.stanragets.com

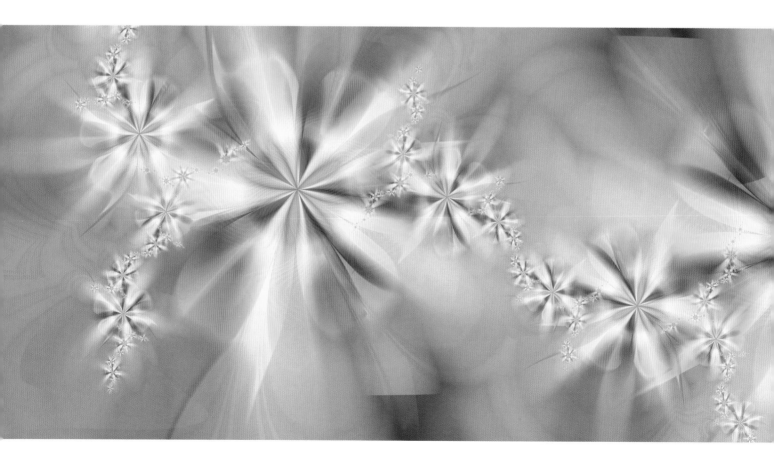

Winter Flower, 2011. 20" x 40", digital fractal image. *Photo courtesy of the artist.*

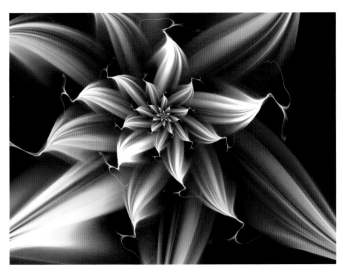

Summer, 2008. 8" x 10", digital fractal image.
Photo courtesy of the artist.

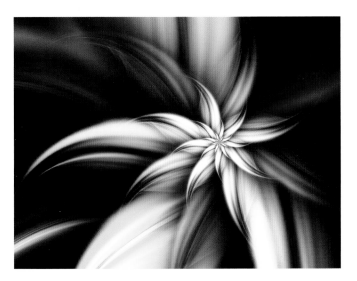

Colors of Home, 2010. 8" x 10", digital fractal image.
Photo courtesy of the artist.

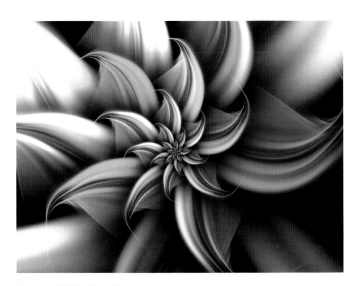

Rolling, 2008. 8" x 10", digital fractal image.
Photo courtesy of the artist.

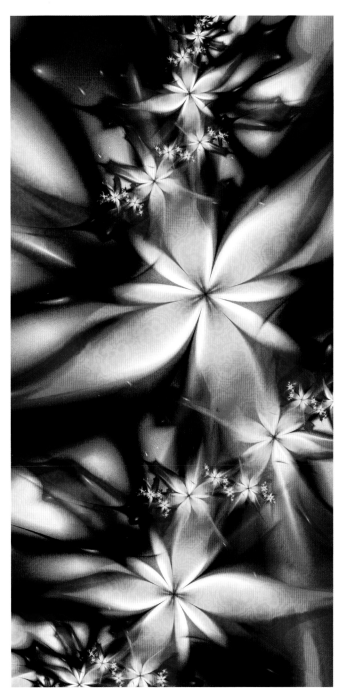

Fire Flower, 2010. 84" x 42", digital fractal image.
Photo courtesy of the artist.

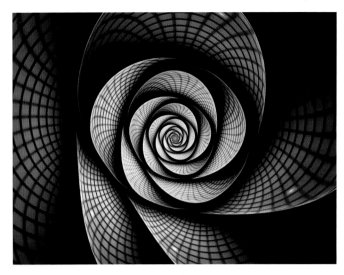

Separation, 2010. 8" x 10", digital fractal image.
Photo courtesy of the artist.

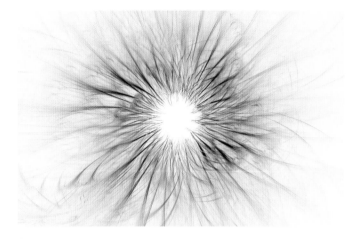

Embrace, 2010. 9.5" x 15", digital fractal image.
Photo courtesy of the artist.

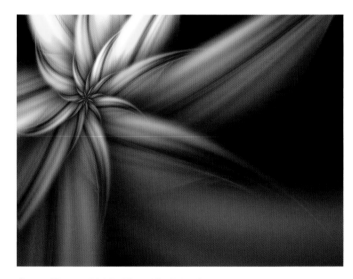

Green Flower, 2008. 8" x 10", digital fractal image.
Photo courtesy of the artist.

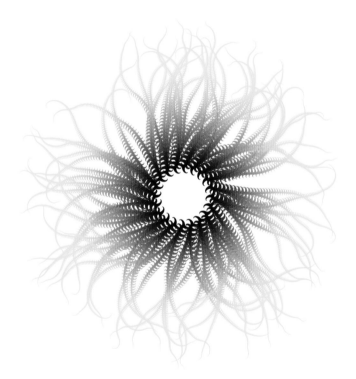

Sunflower, 2008. 25" x 25", digital fractal image.
Photo courtesy of the artist.

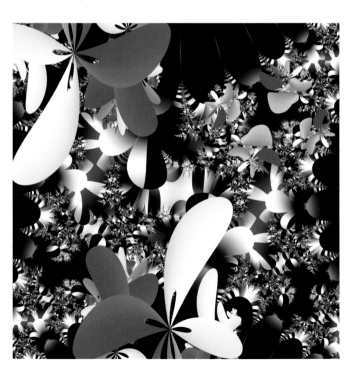

Gentiana, 2008. 14" x 14", digital fractal image.
Photo courtesy of the artist.

Michele Billman

Angola, Indiana, United States

I started taking digital photos of flowers around 2006 to help document the flowers around our house so my mom could see them. It was my way of helping my mom stay connected to the outside world after she suffered a stroke in 2005. My mom suggested creating artwork out of the flowers to bring the outside world inside the house for her to enjoy all year long.

I am an artist who enjoys symmetrical pieces of artwork so I like to reflect my images, creating a perfectly balanced new world. The newly reflected pieces of artwork started revealing hidden images as I stared at them for a few minutes with soft focused eyes. Angels often show up in my creations unexpectedly. I never make a conscious effort to add angels but they often appear as hidden images when you least expect them during the creative process. The angelic images were confirmation that God was hearing my prayers and that taking on the responsibility of caring for my elderly mother was where my family needs to be for now.

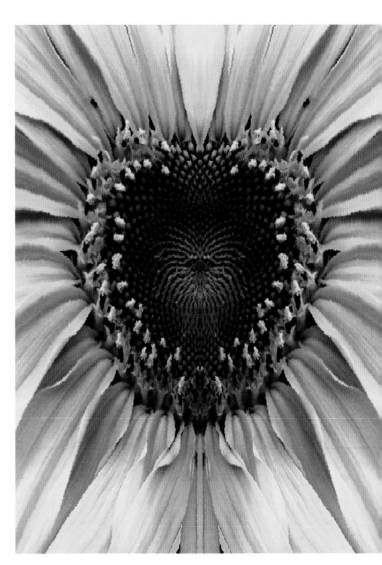

Sun Power, 2011. 20" x 30", digital photograph.
Photo courtesy of the artist.

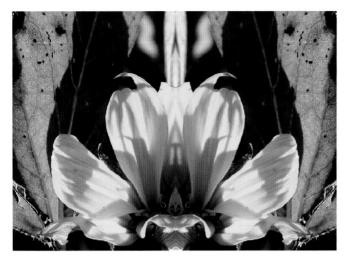

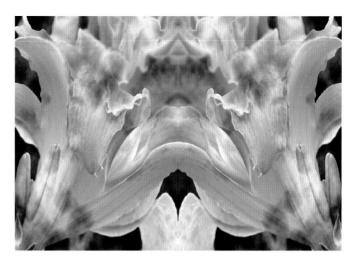

Sacred Light, 2011. 20" x 30", digital photograph.
Photo courtesy of the artist.

Garden Angels, 2011. 20" x 30", digital photograph.
Photo courtesy of the artist.

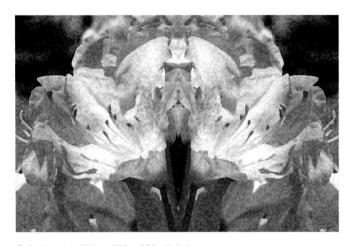

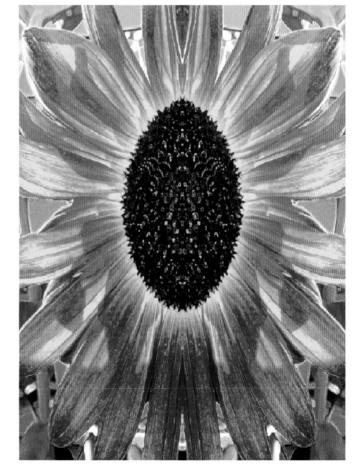

Enlightened, 2011. 20" x 30", digital photograph.
Photo courtesy of the artist.

Inner Light, 2011. 20" x 30", digital photograph.
Photo courtesy of the artist.

Meditation, 2011. 20" x 30", digital photograph.
Photo courtesy of the artist.

Mother Earth, 2011. 20" x 30", digital photograph.
Photo courtesy of the artist.

Manifest, 2011. 20" x 30", digital photograph.
Photo courtesy of the artist.

Spirited Energy, 2011. 20" x 30", digital photograph.
Photo courtesy of the artist.

Cheryl Garcia

Denver, Colorado, United States

Why do I feel compelled to paint flowers? When I look at a flower in nature (and all of these paintings are of flowers in their natural habitat) my reaction is always very visceral and sensual. My friends laugh at me because the first thing I do is touch the petals of the flower. I do this because I need (yes, need) to feel how smooth and thick the petals are and whether they have any hidden textures. Often I touch my cheek or lips to the flower because to me it feels like skin touching skin. At the same time I am very aware of how the flower smells. Even if it isn't fragrant in the traditional sense, I can still smell something. Often it is just that fresh smell that you get upon entering a really good florist and you smell a jumble of scents.

I paint flowers to pay homage to them and mother nature for having created such wonders. And I paint flowers because while I'm painting them I can bring back the visceral, sensual feelings I felt the first time I saw the flower and that brings me pleasure.

WEBSITE: www.cherylgarciaart.com

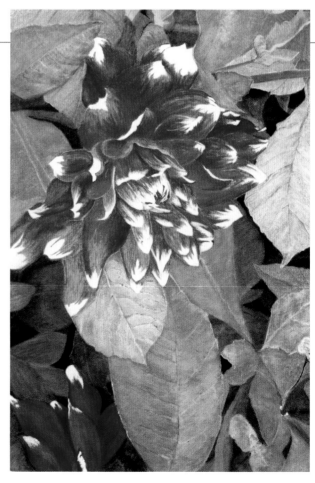

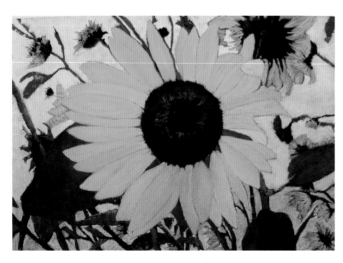

Sunflower, 2010. 19" x 25", painting, soft pastels on Kitty Wallis sanded paper. *Photo courtesy of Victoria Erickson.*

Dahlia, 2010. 30" x 26", painting, soft pastels on sanded cold press watercolor paper. *Photo courtesy of Victoria Erickson.*

Dia Spriggs

Miami, Florida, United States

I love to work with nature, as it brings me closer to the simplicity of life. Looking closely at the beauty of flowers reveals so many colors, textures, and parts that allow the flower to enable the plant to survive and reproduce. There is such a peace and tranquility to be surrounded by the color and fragrance of flowers.

WEBSITE: www.artbydia.net

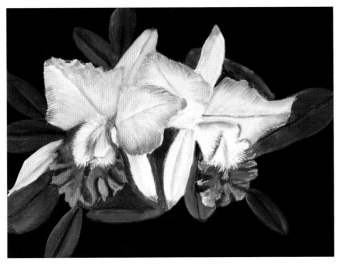

Purple Orchids, 2011. 9" x 12", acrylic painting.
Photo courtesy of the artist.

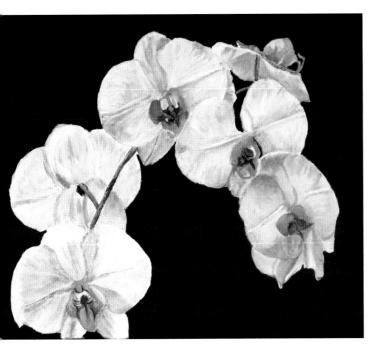

Orchid Spray, 2011. 9" x 12", acrylic painting.
Photo courtesy of the artist.

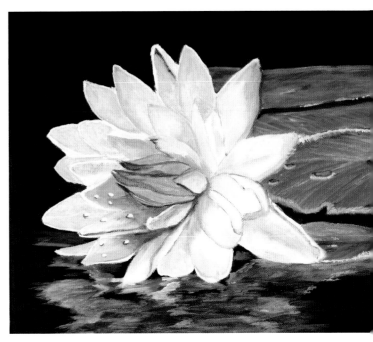

Water Lilly, 2011. 9" x 12", acrylic painting.
Photo courtesy of the artist.

Ekaterina Popova

Wilmington, Delaware, United States

My paintings are derived from the memories of my childhood in Russia. They often focus on a fantastical world which can only exist in one's memory. When I paint the landscape of the Russian countryside, I often embed imaginary flowers, supplemented by otherworldly color. The flowers hold special meaning to me, and are often used as a visual marker, a highlight where it's least likely to appear. Most of the blossoms I paint are imagined, though they may be reminiscent of an actual plant.

WEBSITE: www.kpopovaart.com

U Babushki, 2011. 48" x 36", oil painting on canvas. *Photo courtesy of the artist.*

V Ozhidaniye, 2011. 36" x 48", oil painting on canvas, 2011. *Photo courtesy of the artist.*

Untitled Dacha, 2010. 16" x 13", oil painting on a panel.
Photo courtesy of the artist.

Intersection, 2010. 30" x 17", oil painting on a panel.
Photo courtesy of the artist.

Carolyn Schlam

Taos, New Mexico, United States

I am a figurative artist and the addition of flowers in my work is an added challenge. I am always seeking to capture the moment, the spark of life, and there is no better subject than these evanescent life forms. To capture the fragility of a flower with some oily, greasy paint is a wonder indeed.

For example, the delicate flowers in *Girl with Bouquet* express the loveliness of youth. The girl holding the flowers is unaware of her beauty and freshness much like the flowers she holds. She presents herself to us. I used sunflowers in *Girl with Sunflowers* because they are a fierce flower and I thought they would work well with the moodiness of the figure. Perhaps they influenced the emotional treatment of the girl in the chair. She is sullen and direct and unforgiving, like the sunflowers. She does not present as pretty but as a force to be reckoned with. I try to give an emotional reality to all the live things I paint and this painting shows that sunflowers can be moody too.

WEBSITE: www.carolynschlam.com

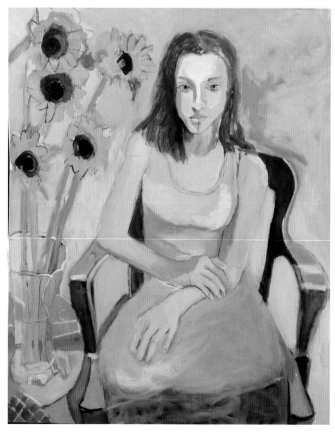

Girl with Sunflowers, 2011. 42" x 34", oil painting.
Photo courtesy of the artist.

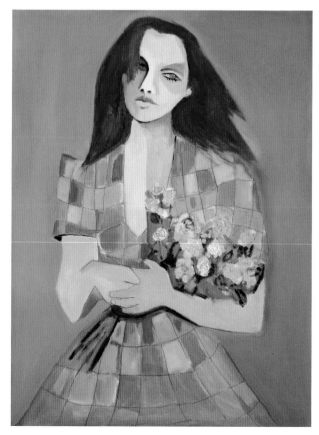

Girl with Bouquet, 2011. 40" x 30", oil painting.
Photo courtesy of the artist.

Sunflower with Red, 2011. 18" x 12", ink and pastel on paper. *Photo courtesy of the artist.*

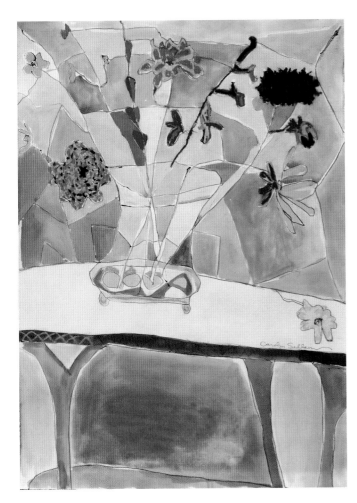

Table with Vase of Flowers, 2011. 30" x 22", ink and pastel on paper. *Photo courtesy of the artist.*

Mary Aslin

Laguna Beach, California, United States

The large majority of my artwork includes flowers by personal necessity for two reasons. The first is that flowers mirror human emotion. Daisies, dancing in the rising sun after a dawn rain shower, evoke stalwart joy and strength. Roses evoke a sense of quiet dignity. Hydrangeas convey lush abundance, each individual petal contributing to the large round cluster. They also convey the beauty of life stages, fresh and vividly colored in the early stages of bloom but then changing, the petal colors becoming iridescent and almost bronze at times but strong, remaining beautiful even when dry. Peonies are pure grace, as they open when their stems bend, and when their petals begin to drop.

The second motivation for including flowers in my work is that they are vehicles for depicting the magic of light and how it organizes line and form into beautiful patterns. The stems, upright or drooping, the blossoms, open, closed, or clustered, catch and organize light in ways that convey pure emotion. Flowers, in concert with light, bring an expansive dynamism to any painting.

WEBSITE: www.maryaslin.com

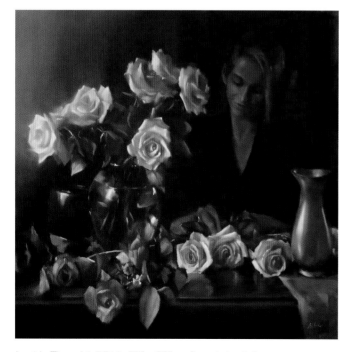

Lost in Thought, 2011. 25" x 26", soft pastel painting.
Photo courtesy of the artist.

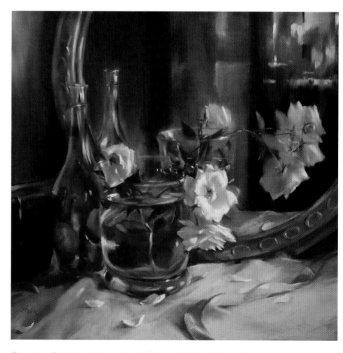

Beauty, Real and Imagined, 2011. 20" x 20", soft pastel painting.
Photo courtesy of the artist.

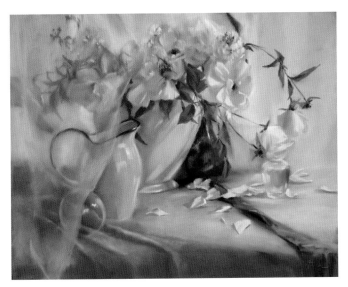

Vale of Tears, 2010. 16" x 20", soft pastel painting.
Photo courtesy of the artist.

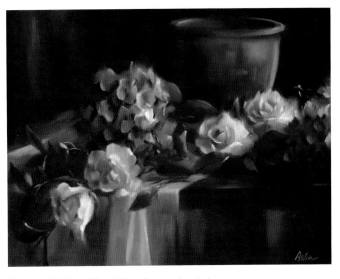

Exalted, 2011. 12" x 16", soft pastel painting.
Photo courtesy of the artist

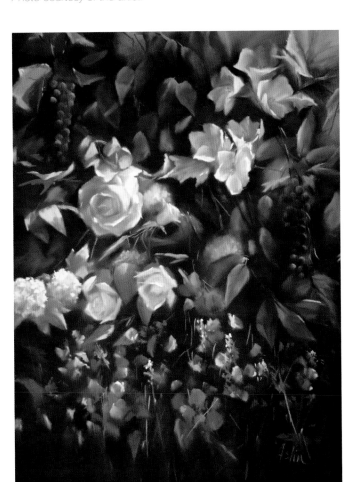

Concerto in the Garden, 2010. 30" x 22", soft pastel painting.
Photo courtesy of the artist.

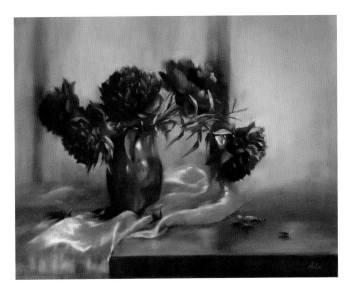

Offering, 2011. 22" x 28", soft pastel painting.
Photo courtesy of the artist.

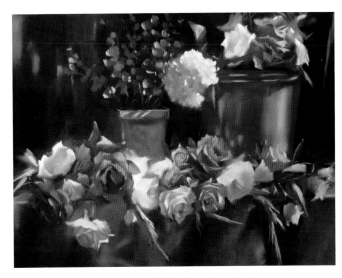

Roses Be Glad, 2010. 18" x 24", soft pastel painting.
Photo courtesy of the artist.

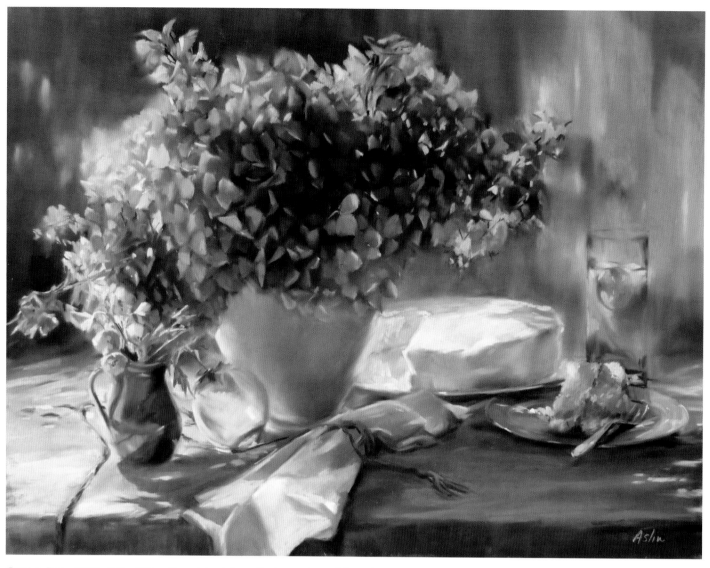

Garden Party, 2011. 20" x 26", soft pastel painting. *Photo courtesy of the artist.*

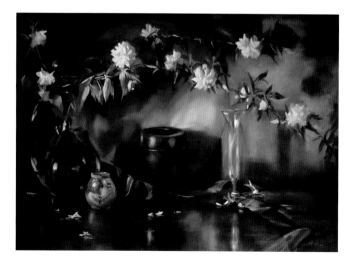

Lyricism, 2011. 16" x 22", soft pastel painting.
Photo courtesy of the artist.

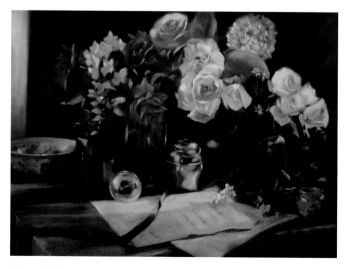

Mozart's Delight, 2010. 22" x 30", soft pastel painting.
Photo courtesy of the artist.

Joseph J. O'Neil

Alexandria, Virginia, United States

Although my vision as a photographer has constantly changed throughout the years, I am currently interested in trying to find beauty and character in items I find on the street and in nature. I think of myself as being a passionate observer of the ordinary. I look at the relationship of light, shadow, and form of simple leaves, flowers, and other ordinary objects I find. In actuality I truly believe that these objects present themselves to me, rather than me finding them. The excitement to me is creating compositions from these various items and making something unexpected. A major influence has always been the lighting that I found in many old master painters and their use of chiaroscuro within their work. The background I typically use is usually white or black, to draw attention to the subject and to encourage its evaluation by the viewer.

WEBSITE: www.flickr.com/photos/oneilimages/show/

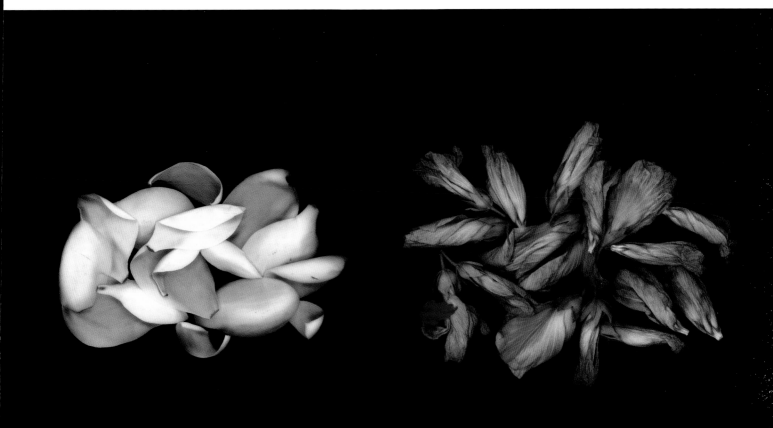

White Magnolia Petals #7B, 2010. 9.5" x 15.5", digital photograph.
Photo courtesy of the artist.

Purple Buds #1, 2010. 7.5" x 10.2", digital photograph.
Photo courtesy of the artist.

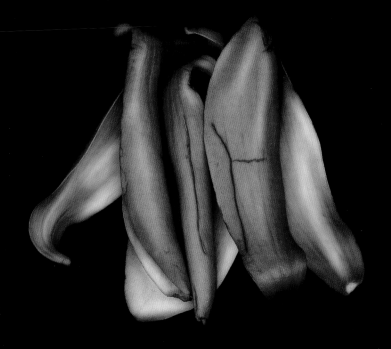

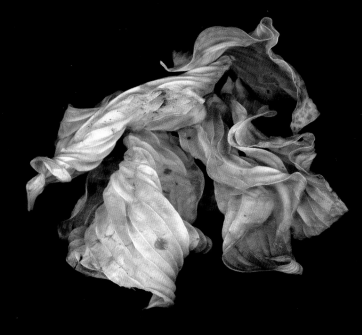

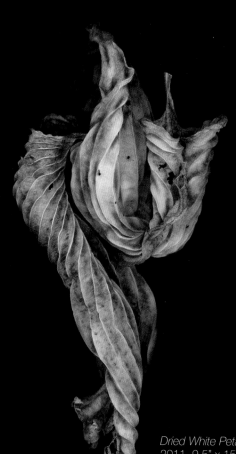

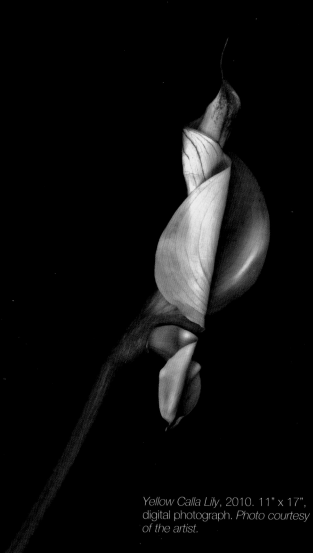

Red Petals, 2010. 7.4" x 10", digital photograph.
Photo courtesy of the artist.

Dried White Petals #9, 2011. 9.5" x 15.5", digital photograph.
Photo courtesy of the artist.

Dried White Petals #18,
2011. 9.5" x 15.5", digital
photograph. *Photo courtesy
of the artist.*

Yellow Calla Lily, 2010. 11" x 17",
digital photograph. *Photo courtesy
of the artist.*

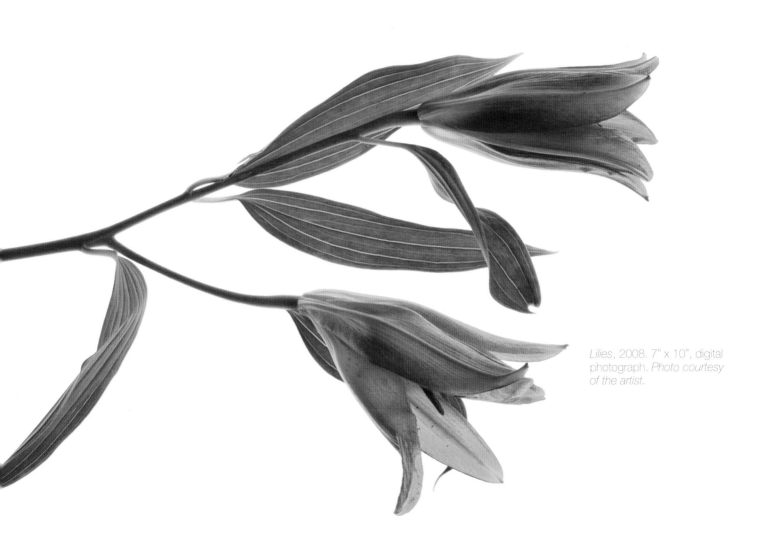

Lilies, 2008. 7" x 10", digital photograph. *Photo courtesy of the artist.*

Pam Borrelli

San Francisco, California, United States

Among the various subjects I am drawn to, I am especially aware of an essence in flora, finding in each a unique individuality and an underlying presence of universal force. The cycle of seed to blossom to bloom to seed again is a profound metaphor of the powers that impel all life. To capture a moment in the life of a flower is to reveal hidden beauty, an attempt to evoke recognition of the ethereal in the natural.

Using an expanding palette of digital enhancements, I strive to create images balancing the delicate with the sublime, which will at once resonate in both mind and heart. When successful, I believe that I have achieved an image that reveals a perception beyond the observable. I use a macro lens and implement HDR (High Dynamic Range) technology in my work.

WEBSITE: www.borrelliportraits.com

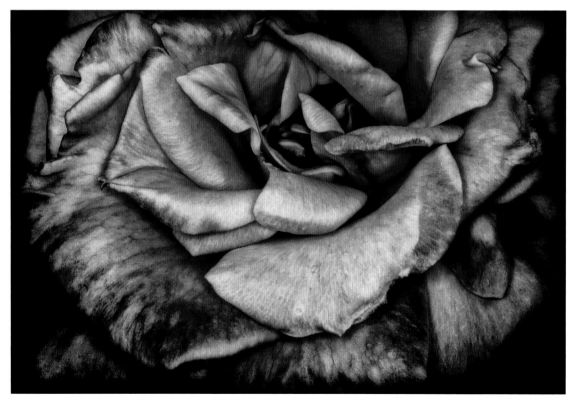

Golden Rose, 2010. 24" x 36", giclee photograph. *Photo courtesy of the artist.*

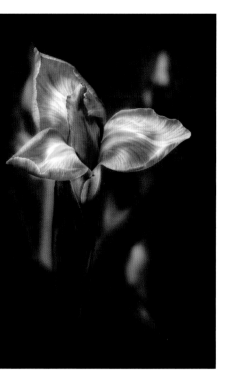

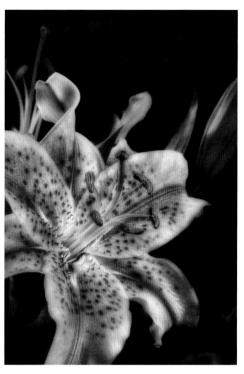

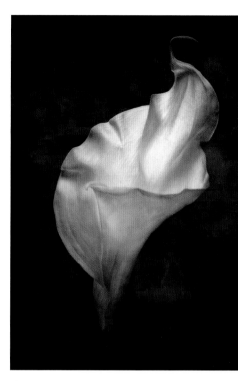

Blooming Iris, 2010. 18" x 12",
photograph. *Photo courtesy
of the artist.*

Pollen Ready, 2010. 18" x 12", photograph.
Photo courtesy of the artist.

Calla, 2011, 40" x 30", giclee
photograph. *Photo courtesy of the
artist.*

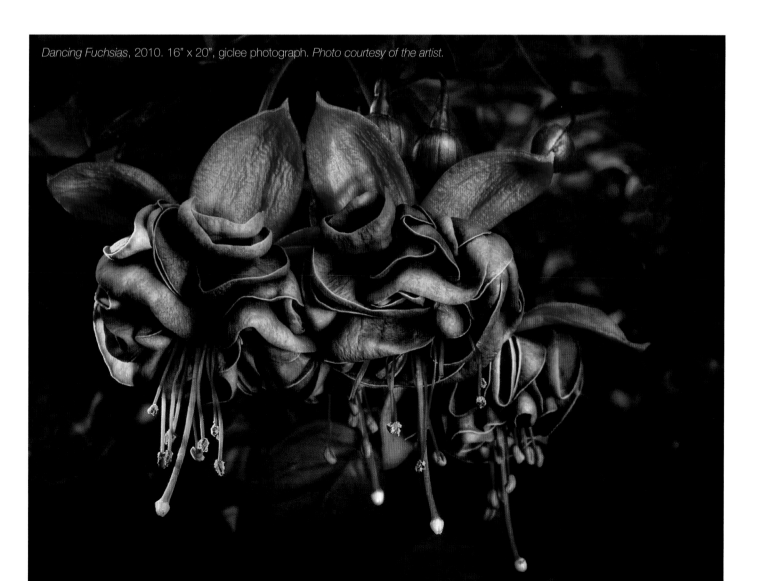

Dancing Fuchsias, 2010. 16" x 20", giclee photograph. *Photo courtesy of the artist.*

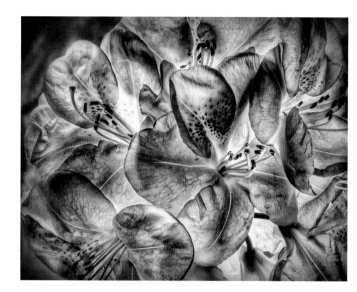

Amethyst, 2009. 15" x 20", photograph.
Photo courtesy of the artist.

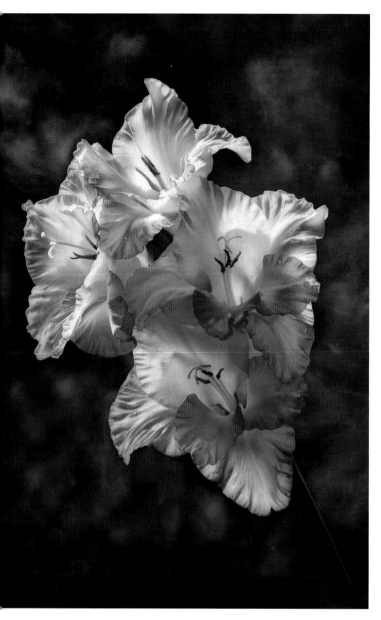

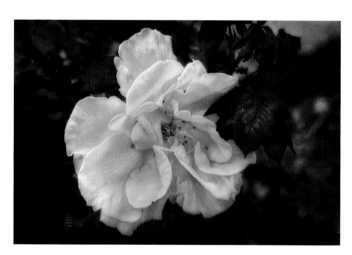

Sweet Fragrance, 2009. 24" x 36", giclee photograph.
Photo courtesy of the artist.

Last Bloom, 2011. 18" x 12", photograph.
Photo courtesy of the artist.

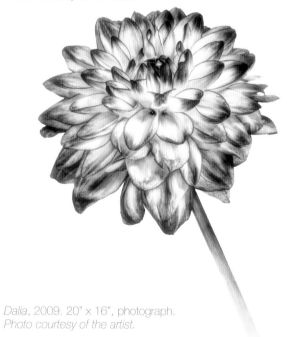

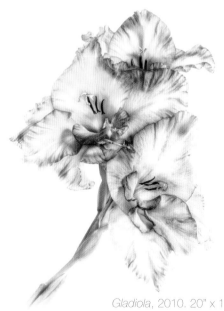

Dalia, 2009. 20" x 16", photograph.
Photo courtesy of the artist.

Gladiola, 2010. 20" x 16", giclee photograph.
Photo courtesy of the artist.

Ilona Battaglia Aguayo

Los Angeles, California, United States

Happiness comes from appreciating and recognizing what we have. Life is full of beauty. You don't need to go farther than your backyard to find it. That is where I find the inspiration for my floral paintings. I was born and raised in Fairview, New Jersey, so my exposure to cactus prior to my move to California was a Christmas Cactus I tried to keep alive in my kitchen window. I now enjoy an entire cactus garden in my backyard which takes care of itself.

WEBSITE: www.illona.net

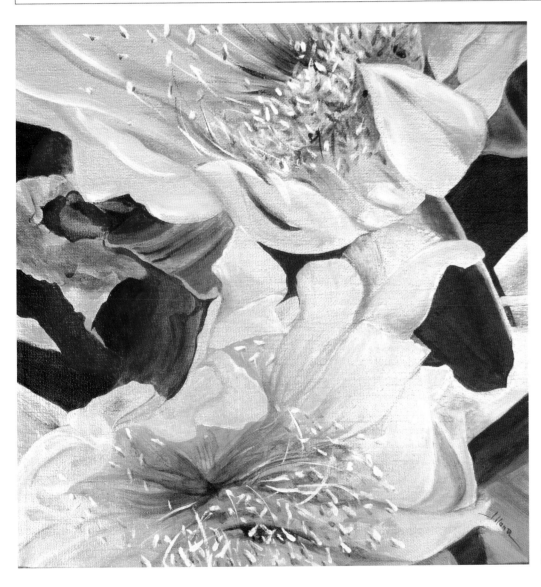

Cactus Flowers I, 2011. 12" x 12", acrylic painting on canvas. *Photo courtesy of the artist.*

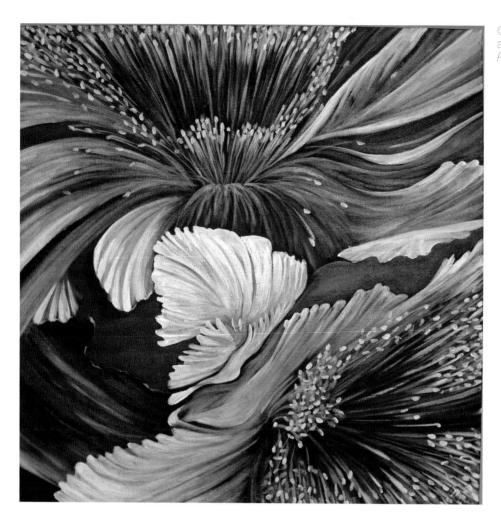

CactusFlowers II, 2011. 30" x 30",
acrylic painting on canvas.
Photo courtesy of the artist.

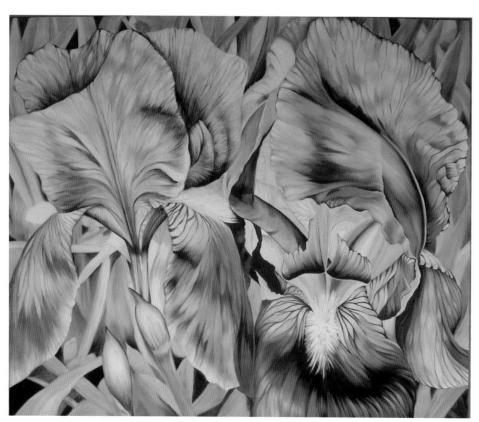

Alone Together, 2011. 60" x 72",
oil painting on canvas.
Photo courtesy of the artist.

Jeannette Cuevas

Pleasanton, Texas, United States

I am totally inspired by the way sunlight can transform a delicate blossom into a vibrant spot of glowing brightness. Viewing the intensity of light that transcends colorful petals is absolutely mesmerizing and I am compelled to capture the warmth and vibrancy that is produced by that light. I think this is why I enjoy painting this subject so much. Flowers are naturally beautiful in their own right but when influenced by the light from above, we begin to see colors, shapes, and surfaces that reflect and refract light much like a prism and continue beyond the surface to illuminate the beauty within.

My passion is exposing that underlying beauty and that is probably the main reason I am drawn to using layers of watercolor washes for the foundation on which to lay in my pastel images. The loose, bold strokes of colors provide what I call the "soul of the painting." These colors ultimately peek through the final layers of pastel creating a depth of life that seems to glow from within and blossoms that glitter with light.

WEBSITE: www.jeannettecuevas.com

Remembrances of South Texas, 2010. 27" x 48", pastel over acrylic painting. *Photo courtesy of the artist.*

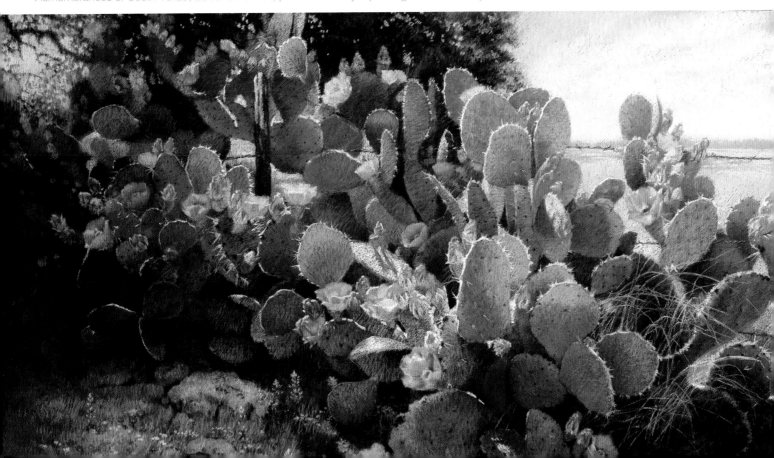

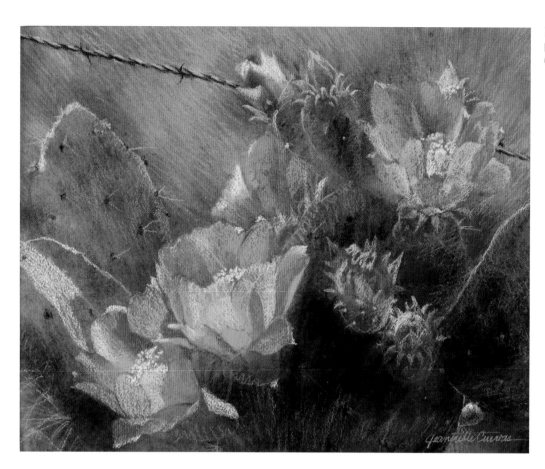

Texas Roses, 2010. 14" x 18", pastel over watercolor painting. *Photo courtesy of the artist.*

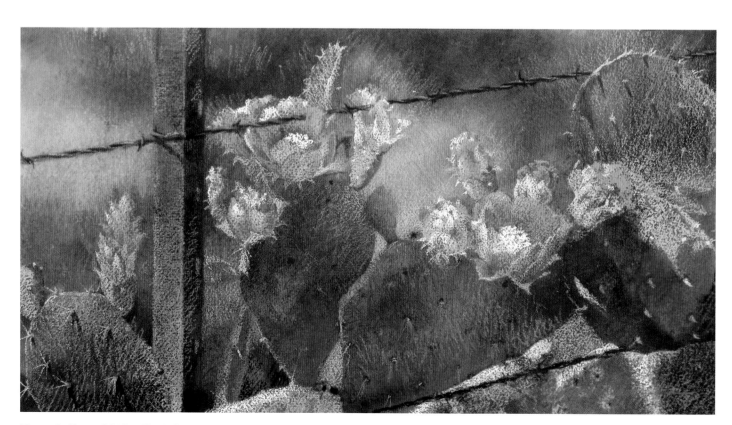

Flores de Fiesta, 2010. 12" x 21", pastel over watercolor painting. *Photo courtesy of the artist.*

Cindy Ann Coldiron

Arlington, Virginia, United States

I have honestly never met a flower that I did not like. Every year I like to see how many kinds of flowers I can squeeze into my townhouse yard. Everything, from heirloom bourbon roses which look like peonies to orange tiger lilies, provides an inspiration for me to capture them in a permanent photo. Digital photography allows for such a variety of technical enhancements that you can also create dynamic new flower images that are only loosely based on the original image.

I am especially drawn to boldly colored flowers and enjoy watching the playfulness of the butterflies in my zinnias. Capturing a perfect image of a Virginia Swallowtail butterfly resting on a bright pink zinnia shows me that my little ecosystem created a welcome habitat.

WEBSITE: artist-cindyann.tripod.com/Aportfolio/

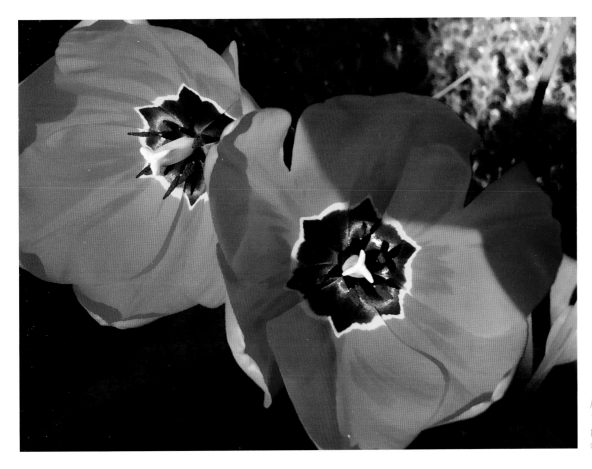

Poppy Tulips, 2011.
16" x 20", digital
photograph. Photo
courtesy of the artist.

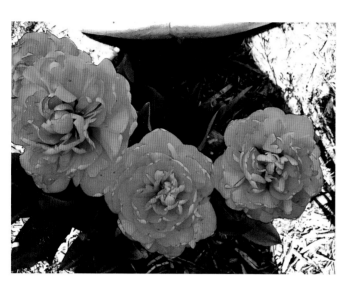

Peony Tulips, 2010. 16" x 20", digital photograph
Photo courtesy of the artist.

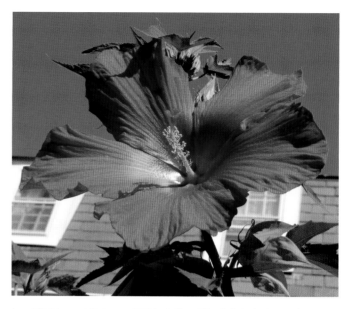

Lord Baltimore Hibiscus, 2011. 14" x 16", digital photograph.
Photo courtesy of the artist.

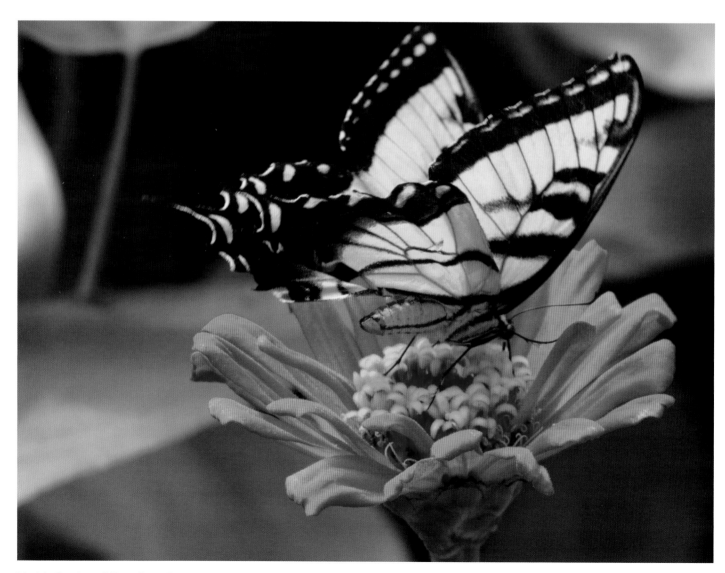

Virginia Swallowtail Butterfly on Pink Zinnia, 2009. 16" x 22", digital photograph. *Photo courtesy of the artist.*

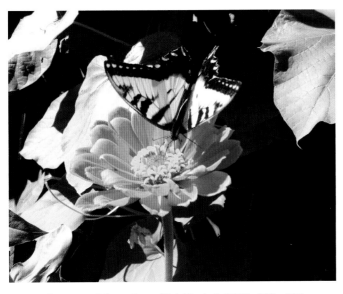

Virginia Swallowtail Butterfly on Pink Zinnia II, 2009. 28" x 36", digital photograph. *Photo courtesy of the artist.*

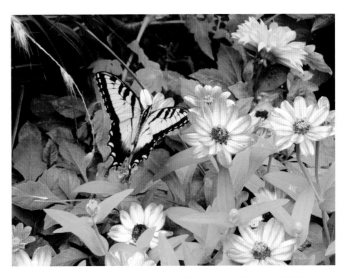

Virginia Swallowtail Butterfly on Pink Thumbelina Zinnia, 2009. 16" x 22", digital photograph. *Photo courtesy of the artist.*

Replete Daffodils, 2009. 27" x 36", digital photograph. *Photo courtesy of the artist.*

Purple Petunia Party, 2009. 42" x 32", digital photograph. *Photo courtesy of the artist.*

Amy Vangsgard

Los Angeles, California, United States

In my artwork, I try to capture that fleeting, magical moment when the light illuminates flowers in such a way that they come to life. In all of my artwork, whether it is sculptures, painting, or photography, I am attracted to the brilliance of color. And nothing exudes color more in nature than flowers. But flowers, like light, are fleeting. Finding the exact moment when the light illuminates an evanescent creation in nature inspires me to look high and low for the next brilliant moment in life.

Capturing that special image in time is just the first step in my artistic process. But what makes my digital artwork unique is the technique I use to transform each image into my impression of that magical moment. I upload the digital photography to PhotoshopCS3 to create a digital painting. Using color, contrast, and textures, I work on my digital art to recreate the feeling I had when I first saw magnificent flowers blooming with sunlight illuminating them from behind.

WEBSITE: www.Amyvangsgard.com

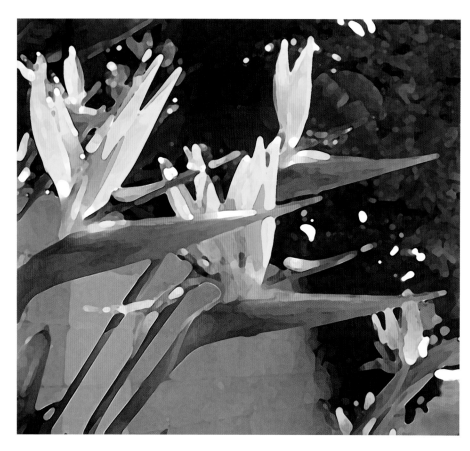

Bird of Paradise Backlit by Sun, 2009. 40" x 36", digital art. *Photo courtesy of the artist.*

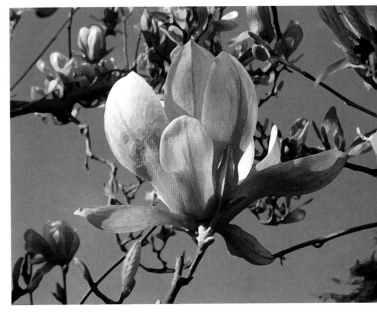

Pink Tree Blossoms, 2009. 29" x 37", digital art.
Photo courtesy of the artist.

Magnolia Blossom, 2009. 37" x 27.75", digital art.
Photo courtesy of the artist.

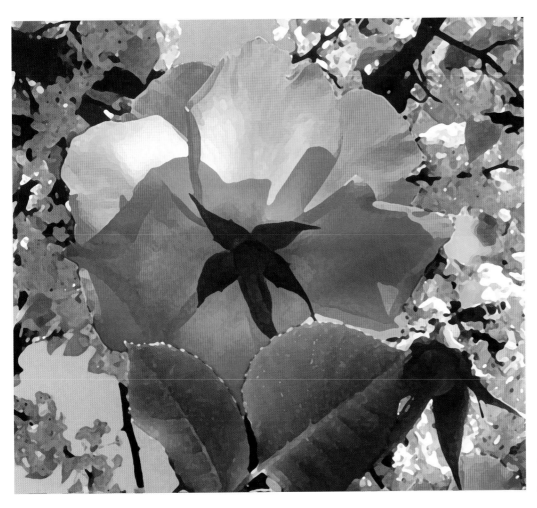

Looking Up at Rose and Tree,
2009. 40" x 36", digital art.
Photo courtesy of the artist.

Veronica Winters

State College, Pennsylvania, United States

My vivid colored pencil drawings feature glimmering objects and textural surfaces, and fragile flowers that are complex and intriguing set ups. Those are my fine studies of light and shade, texture, and glass. These drawings frequently capture airy, illusive feelings of fragility found in nature. Elegant curves of petals, textural centers of flowers, and vibrant colors all evoke mystical, beautiful feelings that I try to translate onto paper when drawing.

My sense of color, compositional unity, and, often, surreal narrative has matured in a long process of constant drawing. Drawing that is physically laborious and emotionally intense. The process of realistic drawing requires fundamental knowledge of techniques coupled with daily practice. I've been drawing with colored pencils for over a decade, favoring them for unbeatable precision and accuracy in color mixing. I create art based on the environment I'm living in for a period of time.

I fuse realistic objects with a hint of surrealism, where my ideas for paintings symbolize personal feelings, emotions, history, and aura of life.

In still life drawing, I enjoy building elegant compositions around simple décor objects that become visual anchors on paper. For me, flowers have ephemeral beauty, whereas marbles represent circles of life. Marbles' semi-transparent appearance is just as complex and intriguing to draw as the crystal surface of vases. Cut flowers evoke sensual, delicate, and fleeting human emotions that become drawings of sophisticated precision.

WEBSITE: www.Veronicasart.com

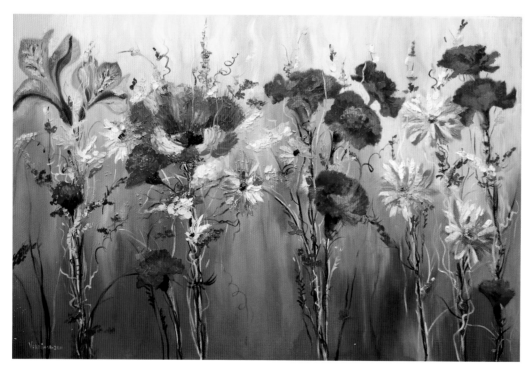

Flowers on Yellow and Blue,
2011. 24" x 36", oil painting.
Photo courtesy of the artist.

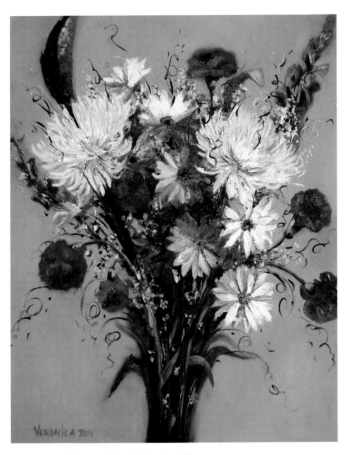

Happiness, 2011. 18" x 24", oil painting.
Photo courtesy of the artist.

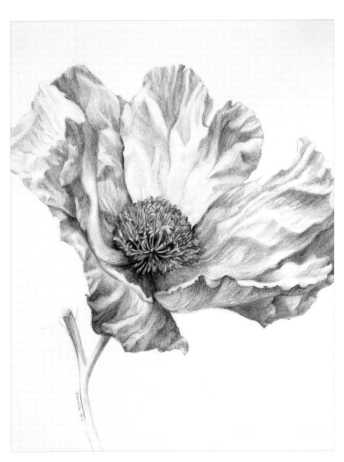

Popover, 2010. 11" x 14", colored pencil drawing.
Photo courtesy of the artist.

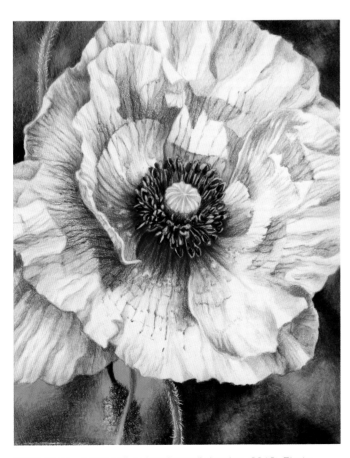

White Poppy, 11" x 14", colored pencil drawing, 2010. *Photo courtesy of the artist.*

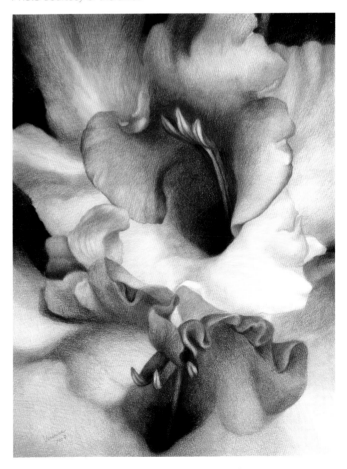

Gladiolus, 2007. 19" x 25", colored pencil drawing.
Photo courtesy of the artist.

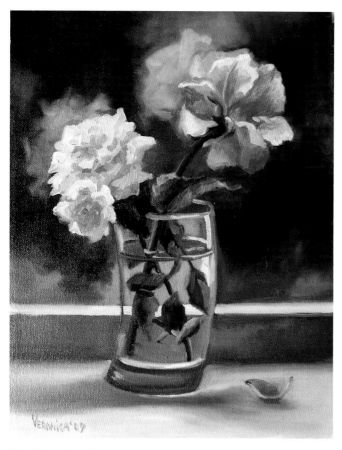

Two Roses in a Crooked Vase, 2009. 11" x 14", oil painting.
Photo courtesy of the artist.

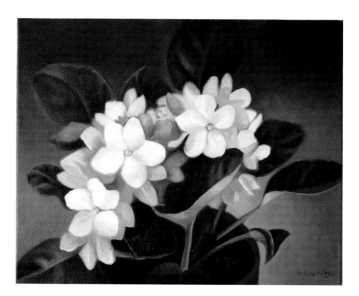

White African Violet, 2010. 11" x 14", oil painting.
Photo courtesy of the artist.

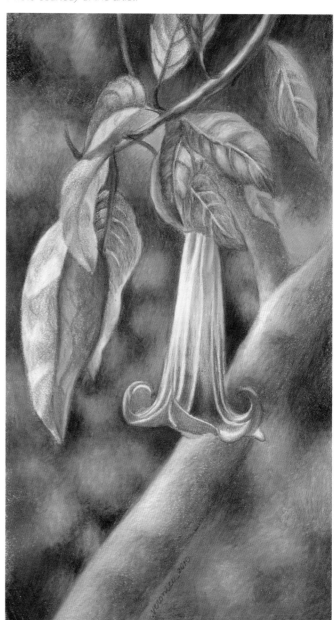

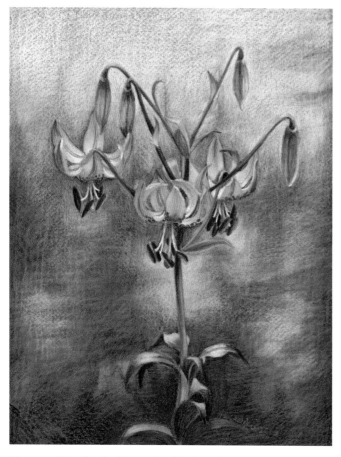

Flowers of the Smoky Mountains, 2010. 11" x 14", colored pencil
drawing *Photo courtesy of the artist.*

Tropical Flower, 2010. 6" x 12", colored pencil drawing.
Photo courtesy of the artist.

Dániel Csóka

Zalaegerszeg, Hungary

Flower photography is really close to me, because it set me on the road of photography. When I bought my first digital camera, my first photographs were taken of flowers. Then my photography evolved to its present state, where I take pictures of everything that I find interesting and beautiful, whether it's nature, flower, or portrait photography. I try to show how beautiful flowers are by taking a closer look at them. My main goal is to create emotions within people's hearts.

WEBSITE: www.fineartamerica.com/art/all/daniel+csoka/all

Carnation, 2009. 12" x 16", photograph. *Photo courtesy of the artist.*

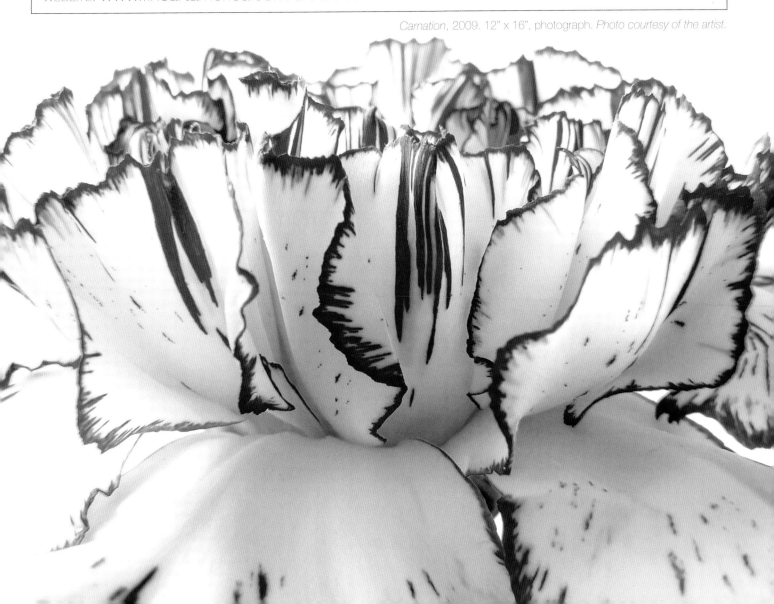

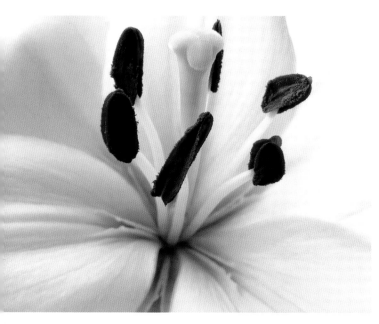

Lily, 2009. 12" x 16", photograph. *Photo courtesy of the artist.*

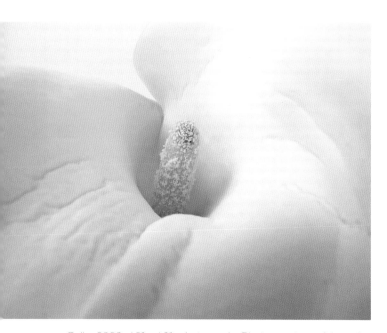

Calla, 2009. 12" x 16", photograph. *Photo courtesy of the artist.*

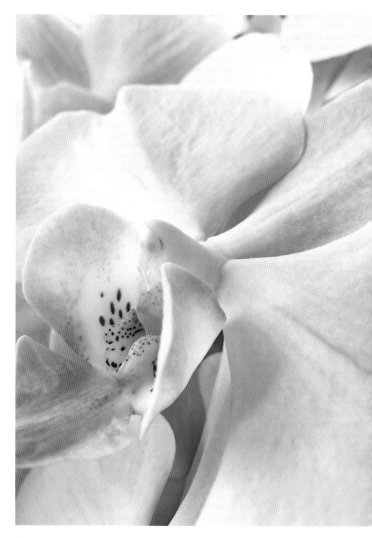

Orchid, 2009. 12" x 16", photograph. *Photo courtesy of the artist.*

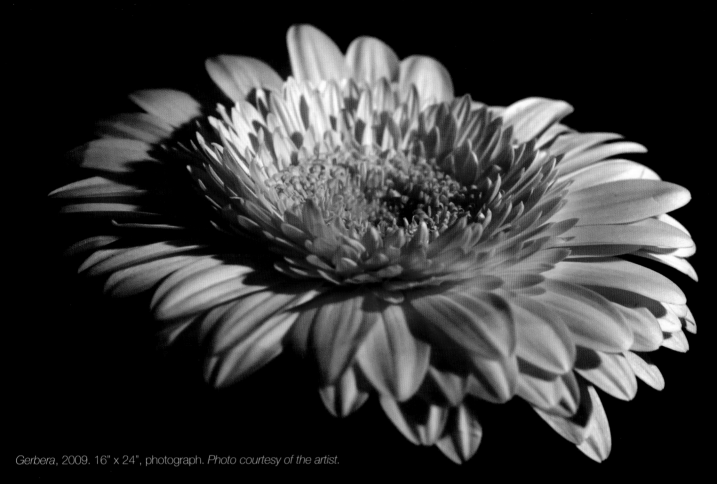

Gerbera, 2009. 16" x 24", photograph. *Photo courtesy of the artist.*

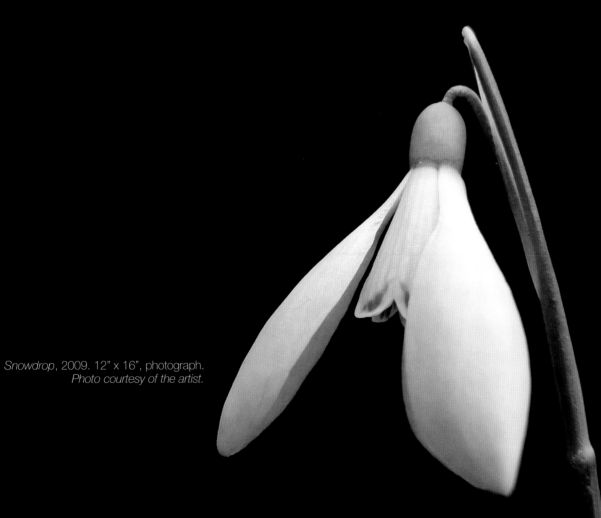

Snowdrop, 2009. 12" x 16", photograph.
Photo courtesy of the artist.

Jennifer Peck

Culver City, California, United States

I have discovered that beauty is a necessity in my life. Flowers evoke feelings of happiness in their colors, awe and wonder in the myriad forms that arise in nature, love that such beauty exists, and knowing that a flower is ephemeral. In photographing a flower, I am able to capture a specific moment in time, never to be repeated exactly in nature again.

As an artist, photographer, and an avid gardener, I feel a strong connection when I plant in the earth and watch the life cycle of a flower. I get to create and participate in the process of life. When I photograph, I acknowledge the existence of this life form and, through my senses and camera, I reveal my own perspective. I love the sheer beauty of flowers, but I also love the challenge of seeing the flower with an artist's eye. I feel like I want to crawl inside or to be cradled within the petals of the flower, and the lens of my camera is my avenue inside. Flowers represent all life. They exist, they struggle to survive, they reach for the light, they respond to a bee's caress, they provide a bird's nectar, and they emit odors foul and sweet. They are composed of many layers, revealing contrasts of soft and prickly, sticky and smooth. They are sustainers of life and death. Most of all, their beauty gives me joy.

WEBSITE: www.flickr.com/photos/jpeck-4imaging/

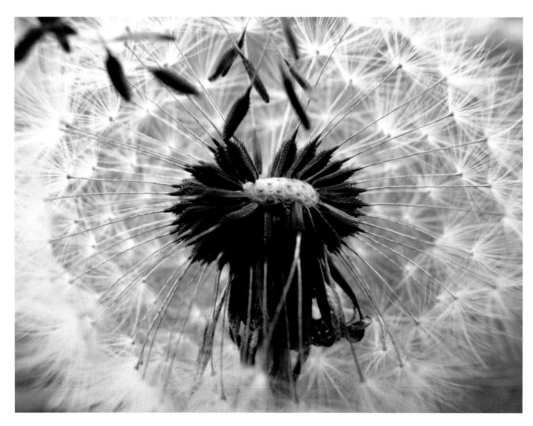

A Thousand Wishes, 2010.
16" x 20", digital photograph.
Photo courtesy of the artist.

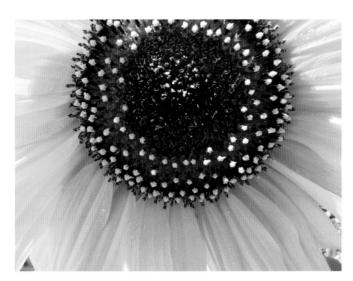

Radiantly Sunny, 2011. 16" x 20", photograph.
Photo courtesy of the artist.

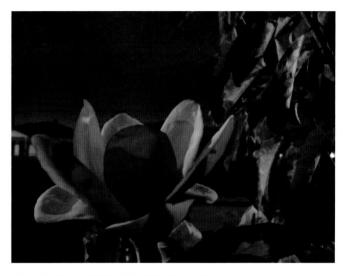

Moon Bathing, 2010. 16" x 20", digital photograph.
Photo courtesy of the artist.

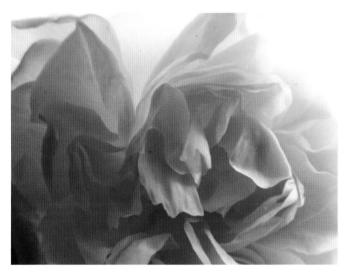

Illuminated, 2011. 16" x 20", digital photograph.
Photo courtesy of the artist.

Bee Blossoms, 2011. 16" x 20", digital photograph.
Photo courtesy of the artist.

First Cut in Spring, 2011. 16" x 20",
photograph. *Photo courtesy
of the artist.*

Mary McGovern

San Antonio, Texas, United States

In my painting process, I strive to get as close to reality as possible. The methods I use to do that can range from 30-40 layers of paint and dozens of hours on pieces like *Iris* and *Carmine* to only 1 or 2 layers of just a few colors on *Viola* and *Cactaceae*. My pieces usually start as photos that I or my mom have taken, so I spend a lot of time at parks and arboretums hunting for pretty flowers.

I think flowers attract me so often because they are nature's version of flashing neon signs. Designed to attract pollinators like insects, birds, and bats, and they only incidentally attract me too. I also enjoy the idea of immortalizing a beautiful, transient blossom that maybe no person but I ever even noticed.

WEBSITE: www.etsy.com/shop/Solochrome

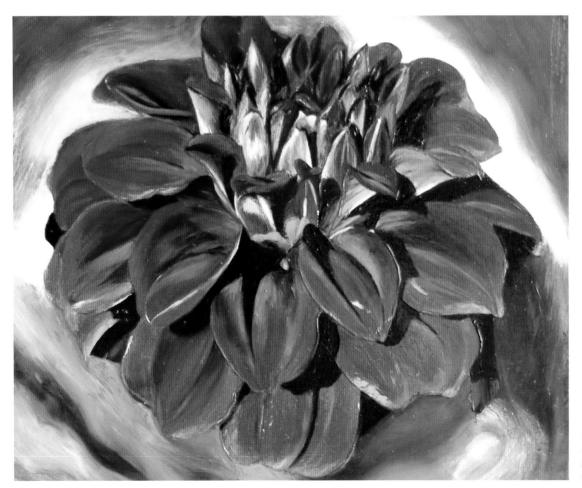

Carmine, 2010. 8" x 10", oil painting on panel. *Photo courtesy of the artist.*

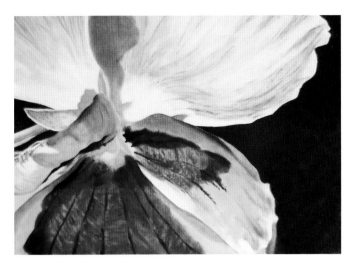

Viola, 2011. 5" x 7", oil painting on panel.
Photo courtesy of the artist.

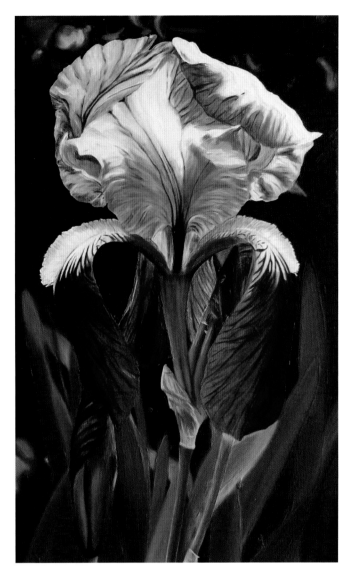

Iris, 2009. 18" x 14", oil painting on canvas.
Photo courtesy of the artist.

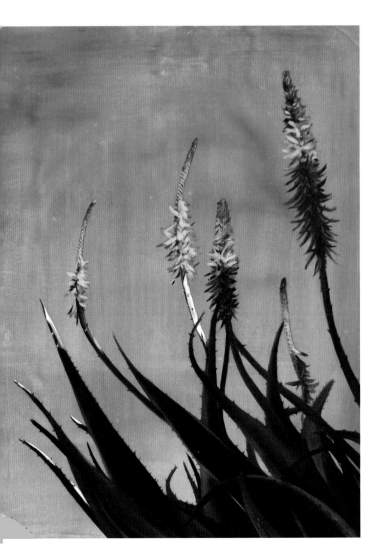

Arboretum, 2010. 20" x 16", oil painting on panel.
Photo courtesy of the artist.

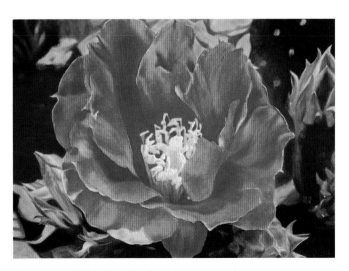

Cactaceae, 2011. 5" x 7", oil painting on panel.
Photo courtesy of the artist.

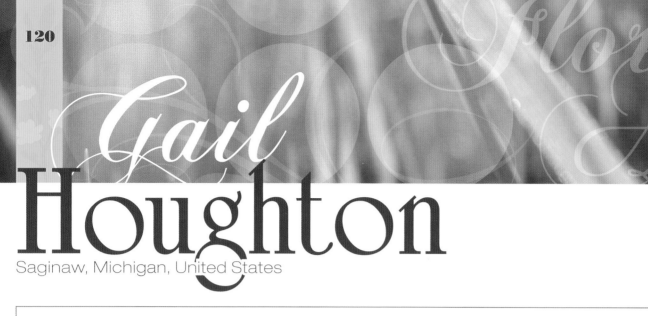

Gail Houghton

Saginaw, Michigan, United States

As a person who sets eyes ablaze, I am riveted by the beauty God has created around me. Flowers have created their own challenge for me as I attempt to capture the magical colors in a captivating way. My photo *Golden Glow* was taken last summer in my aunt's garden after a rain. This ancient name describes this flower as the color yellow "glows." On another occasion, I came upon Faulkner Farm and the front gate was unlocked. I went onto the beautiful Victorian grounds with so many different types of flowers blooming. I circled the house with my finger going non-stop on my camera. The morning glory in the dye garden was a brilliant indigo blue. I found an entire fence of purple passion flowers being hovered over by a hummingbird. The next row of flowers were sunflowers. They weren't just sunflowers though; they were different colors from any I had seen in Michigan. There were peach and orange sunflowers. I must have shot over 300 photos that day. I am happiest when I am lost in the sound of my shutter on my camera.

WEBSITE: www.faithphotosbygail.com

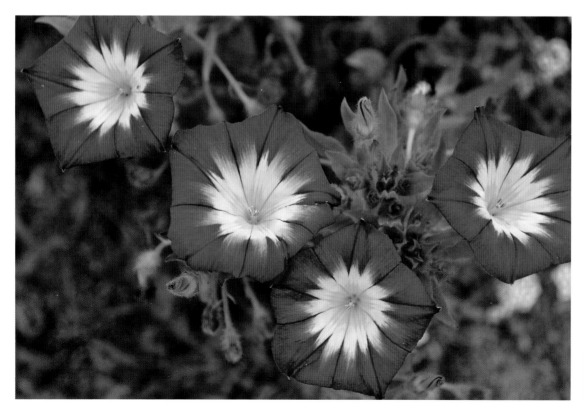

Blue Flower, 2011, 16"
x 24", digital photograph
*Photo courtesy
of the artist.*

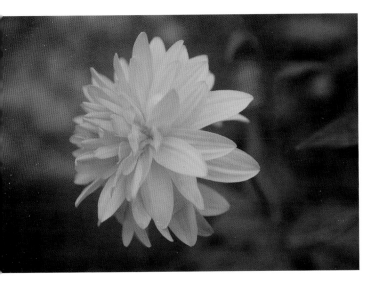

Golden Glow, 2011. 16" x 20", digital photograph.
Photo courtesy of the artist.

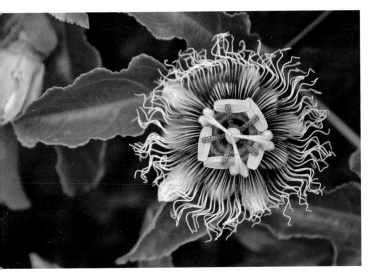

Passion Flower, 2011. 20" x 24", digital photograph.
Photo courtesy of the artist.

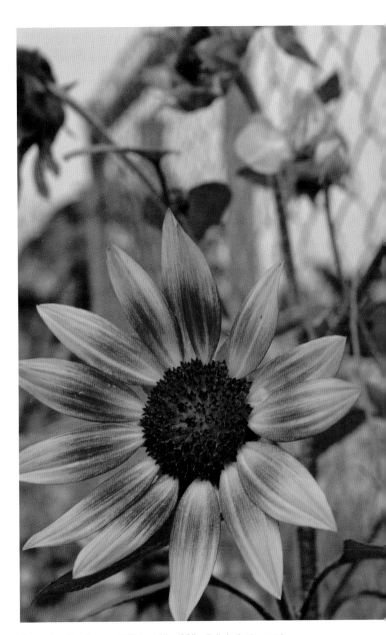

Saturday Sunflower, 2011. 16" x 20", digital photograph.
Photo courtesy of the artist.

Charlie McLenahan

Morayshire, Scotland, United Kingdom

My art uses the medium of photography to show the things that we all see but never look at. My connection with using flowers in my art work goes back to when I was working in horticulture. It was in my horticultural work that I realized that man appears to be in a battle with nature. It was also within this time that I discovered the still life painters from the past including messages in their images via the symbolic meanings of flowers. Most of the meanings have been lost from common use and I spend a lot of time researching the hidden meanings of flowers, also researching their meaning in folklore.

In the image titled *Sentimentum*, the mannequin is taking on a new, formerly unseen persona of the "Grim Reaper" waiting with flowers for the dead. This challenges the concept that in their death they become hidden and ugly. The reaper is the guiding angel for the innocent wildlife that has been prematurely killed by man. In *Hermes and his Staff of Hazel*, the messenger of the Gods Hermes is holding an oversized rod of Hazel. He is a guide to the underworld, the catkins on the Hazel symbolizing love. The appearance of the Hazel wand is also shown as protecting from evil.

The flowers in the *I Sent Flowers* images are to honor the dead. The mannequin in most instances is representing "man," nameless, faceless, and unseeing. Generally in folklore white flowers are for the dead. The little purple flowers, Chionodoxa, glory-of-the-snow, were used since purple is symbolic of helping the dying. The Snowdrops and Snakes Head fritillary in *You Sent Flowers* are symbolic for death.

WEBSITE: www.charlie-mclenahan.com

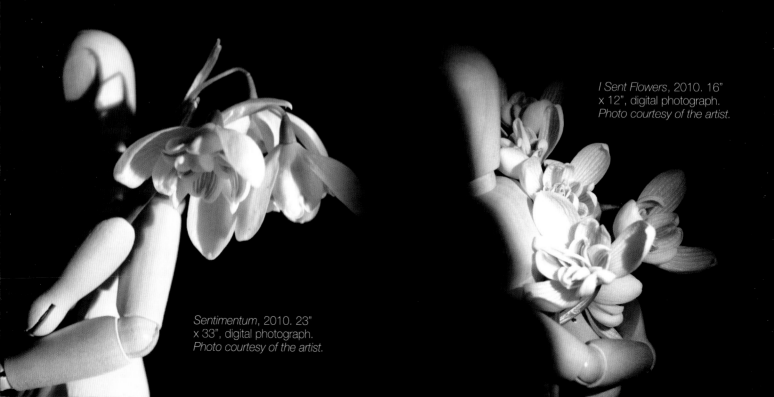

I Sent Flowers, 2010. 16" x 12", digital photograph. *Photo courtesy of the artist.*

Sentimentum, 2010. 23" x 33", digital photograph. *Photo courtesy of the artist.*

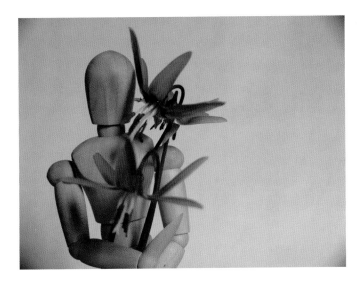

I Sent Flowers, 2011. 23" x 33",
digital photograph. *Photo
courtesy of the artist*

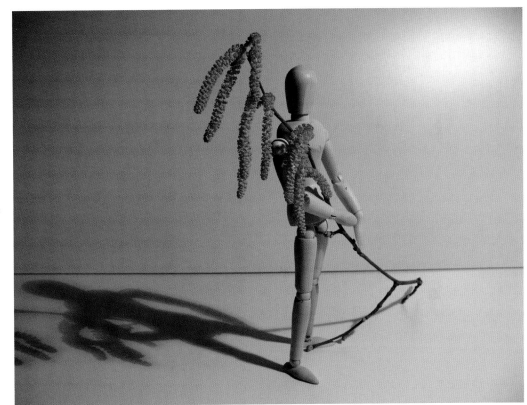

*Hermes and his Staff of Hazel,
2010. 23" x 33", digital photograph
Photo courtesy of the artist.*

*Hermes and his Staff of Hazel,
2010. 23" x 33", digital photograph.
Photo courtesy of the artist.*

You Sent Flowers,
2010. 23" x 33", digital
photograph. *Photo
courtesy of the artist.*

You Sent Flowers,
2010. 23" x 33", digital
photograph. *Photo
courtesy of the artist.*

Conclusion & Flower Quotations

I hope the art profiled in this book showcases the range of emotions that flowers can provoke. Flowers may live a life that lasts only a day or a few weeks but their beauty will always be a beloved subject for artists. From the simple yellow dandelion to the complicated petal filled peony, I cannot imagine our lives without flowers nor without the artists who draw inspiration from these perfections in nature.

I also wanted to share some of my favorite quotes and a favorite poem about flowers.

Autumn is a second spring when every leaf is a flower.
—Albert Camus

I will be the gladdest thing
Under the sun!
I will touch a hundred flowers
And not pick one.
—Edna St. Vincent Millay, "Afternoon on a Hill"

When you have only two pennies left in the world, buy a loaf of bread with one, and a lily with the other.
—Chinese Proverb

I perhaps owe having become a painter to flowers.
—Claude Monet

Sweet April showers do spring May flowers.
—Thomas Tusser

How can there be too many children? That is like saying there are too many flowers.
—Mother Teresa

There are always flowers for those who want to see them.
—Henri Matisse

Flowers are words which even a babe may understand.
—Arthur Cleveland Coxe, "The Singing of Birds"

Each flower is a soul opening out to nature.
—Gerard De Nerval

A morning-glory at my window satisfies me more than the metaphysics of books.
—Walt Whitman

Just living is not enough. One must have sunshine, freedom, and a little flower.
—Hans Christian Andersen

I wandered lonely as a cloud
That floats on high o'er vales and hills,
When all at once I saw a crowd,
A host, of golden daffodils;
Beside the lake, beneath the trees,
Fluttering and dancing in the breeze.
—

Continuous as the stars that shine
And twinkle on the milky way,
They stretched in never-ending line
Along the margin of a bay:
Ten thousand saw I at a glance,
Tossing their heads in sprightly dance.
—

The waves beside them danced; but they
Out-did the sparkling waves in glee:
A poet could not but be gay,
In such a jocund company:
I gazed–and gazed–but little thought
What wealth the show to me had brought:
—

For oft, when on my couch I lie
In vacant or in pensive mood,
They flash upon that inward eye
Which is the bliss of solitude;
And then my heart with pleasure fills,
And dances with the daffodils.
—William Wordsworth, "I Wandered Lonely as a Cloud"

Index to Artists

Endnotes

1. "Flower," Wikipedia, http://en.wikipedia.org/wiki/Flower (last accessed September 4, 2011).

2. "Solving Charles Darwin's Abominable Mystery", Moldowan and his collaborators, research associate Jeremy Dahl and graduate student David A. Zinniker, presented their findings at the annual meeting of the American Chemical Society (ACS) in San Diego on April 2, during a symposium titled, "Biogeochemistry of Terrestrial Organic Matter", http://science.nasa.gov/science-news/science-at-nasa/2001/ast17apr_1/ (last accessed September 4, 2011).

3. "Number of Species Identified on Earth", by Liz Osborn, Current Results Nexus, The World Conservation Union, 2010, "IUCN Red List of Threatened Species: Summary Statistics for Globally Threatened Species. Table 1: Numbers of threatened species by major groups of organisms (1996–2010)", http://www.currentresults.com/Environment-Facts/Plants-Animals/number-species.php (last accessed September 4, 2011).

4. "Herbal Remedies Info: Echinacea Medicinal Uses", http://www.herbalremediesinfo.com/echinacea-medicinal-uses.html, (last accessed September 4, 2011).

5. "Edible Flowers: How To Choose Edible Flowers - Edible Flower Chart", 2010, What's Cooking America, http://whatscookingamerica.net/EdibleFlowers/EdibleFlowersMain.htm (last accessed September 4, 2011).

6. "Edible Flowers: How To Choose Edible Flowers - Edible Flower Chart", 2010, What's Cooking America, http://whatscookingamerica.net/EdibleFlowers/EdibleFlowersMain.htm (last accessed September 4, 2011).

7. "What's Your Sign.Com: The Doorway to Signs and Symbolic Meanings", Zodiac Flower Signs, http://www.whats-your-sign.com/zodiac-flower-signs.html (last accessed September 4, 2011).

8. "Art Symbols Dictionary- Flowers and Plants: The meanings associated with various flowers and plants", by Marion Boddy-Evans, About.com Guide, http://painting.about.com/cs/inspiration/a/symbolsflowers.htm (last accessed September 4, 2011).

9. "Art Symbols Dictionary- Flowers and Plants: The meanings associated with various flowers and plants", by Marion Boddy-Evans, About.com Guide, http://painting.about.com/cs/inspiration/a/symbolsflowers.htm (last accessed September 4, 2011).

10. "Flower Symbolism and Christianity: A Bouquet of History, Flowers in Icons and Faith", March 2, 2010, by Cathlene Smith, http://www.suite101.com/content/flower-symbolism-and-christianity-a208512 (last accessed September 4, 2011).

11. "Symbolism in Hindu Rituals & Worship: What Do Vedic Rituals & Puja Offerings Symbolize?", by Subhamoy Das, About.com Guide, http://hinduism.about.com/od/artculture/a/symbolism_rituals.htm (last accessed September 4, 2011).

12. " Meaning of Flowers in Christian Art", http://www.medieval-life-and-times.info/medieval-art/meaning-of-flowers-in-christian-art.htm (last accessed September 4, 2011).

13. "Ikebana", Wikipedia (last accessed September 4, 2011).

14. "Living Arts Originals- Flower Paintings in the 17th-19th Centuries", http://www.livingartsoriginals.com/infoflowerart.htm (last accessed September 4, 2011).